IMAGES
of America

THE PHILADELPHIA AREA
ARCHITECTURE OF
HORACE TRUMBAUER

Horace Trumbauer (1868–1938) was one of the nation's foremost architects during America's Gilded Age. He masterfully interpreted the classical styles while designing residential and nonresidential buildings. His most famous designs include the Elms for Edward J. Berwind in Newport, Rhode Island; Whitemarsh Hall for Edward T. Stotesbury; and the Philadelphia Museum of Art. In addition to employing the classical styles, Trumbauer designed several art deco buildings in Philadelphia and New York. The Trumbauer firm endured the Great Depression, producing significant projects until Trumbauer's death.

On the cover: Designed by Trumbauer when he was in his late 20s, Lynnewood Hall, built between 1898 and 1900 for P. A. B. Widener, was one of the finest homes in America. Viewed through the formal French gardens of landscape architect Jacques Gréber, Lynnewood Hall was captured in its prime in the early 1920s by photographer Mattie Edwards Hewitt. (Courtesy of the Pennsylvania State Archives.)

IMAGES
of America

THE PHILADELPHIA AREA ARCHITECTURE OF HORACE TRUMBAUER

Rachel Hildebrandt
and the Old York Road Historical Society

ARCADIA
PUBLISHING

Published by Arcadia Publishing
Charleston, South Carolina

Printed in the United States of America

Library of Congress Catalog Card Number: 2008930983

For all general information contact Arcadia Publishing at:
Telephone 843-853-2070
Fax 843-853-0044
E-mail sales@arcadiapublishing.com
For customer service and orders:
Toll-Free 1-888-313-2665

Visit us on the Internet at www.arcadiapublishing.com

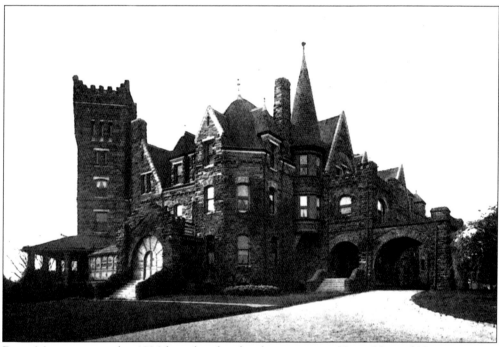

Drum Moir was erected in 1886 for railroad and real estate tycoon Henry Howard Houston. It was designed by the firm of George W. and Willaims D. Hewitt while Horace Trumbauer was employed there. This project—a grand residence for an entrepreneur—may have influenced Trumbauer's career path. Drum Moir, which is listed on the National Register of Historic Places, is extant. It stands at the corner of Willow Grove Avenue and Cherokee Street in Chestnut Hill.

CONTENTS

PREFACE

In October 2006, I received an e-mail from an energetic sophomore at Chestnut Hill College wanting to know if we had sufficient images of Lynnewood Hall to do an Arcadia Publishing book on the subject. She was curious to undertake such a venture independent of her school curriculum. As our initial conversations progressed, we decided to join forces and do a book on Horace Trumbauer's works in the Philadelphia region.

Since then, Rachel Hildebrandt and I, along with other members of our board, have worked through the many issues and obstacles that spring up along the path to publishing a work such as this. Rachel's enthusiasm has never waned, nor has her love for and interest in the topic diminished one bit. She is truly a historian's dream come true, and we are glad to have been her partner in this endeavor.

Horace Trumbauer's ties to the territory covered by the Old York Road Historical Society are long and deep. From his youthful years growing up in Jenkintown to his projects for local clients spanning the entire sweep of his career, Trumbauer is never far from one's mind when surveying our built environment. Indeed, we are fortunate to still have a number of his most significant residential works in our midst.

To our delight, it is part of our responsibility to further the study of and promote such Trumbauer masterpieces. The Old York Road Historical Society was formed in 1936 to study and perpetuate the history and folklore of the communities along and adjacent to the Old York Road from Rising Sun in Philadelphia to New Hope in Bucks County. Over the years, we have focused our efforts and collections on the eight municipalities in the easternmost section of Montgomery County, namely Abington, Cheltenham, Lower Moreland, and Upper Moreland townships and the boroughs of Bryn Athyn, Hatboro, Jenkintown, and Rockledge. As we remain the primary historical repository for these areas, donations of photographs, manuscripts, and other documents and objects related to this area are both strongly encouraged and heartily appreciated. You can discover more about our organization by visiting us on the Web at www.oyrhs.org.

Finally, many thanks for supporting our work through your purchase of this book. May you pass on your interest in this topic to a younger generation so that, with young adults like Rachel, there will be no shortage of people in future generations who appreciate and work to preserve the history that is all around us.

—David B. Rowland,
President, Old York Road Historical Society

ACKNOWLEDGMENTS

This book would not be possible without the help of many individuals and Philadelphia area institutions. Bruce Laverty and Michael Seneca of the Athenæum of Philadelphia, Liz Jarvis of the Chestnut Hill Historical Society, Karen Lightner and Ted Cavanagh of the Free Library of Philadelphia's print and pictures department, Joseph Shemtov and Katharine Chandler of the Free Library of Philadelphia Rare Book Department, Judith Herbst of the Keswick Theatre, Linda Wisniewski and Erika Piola of the Library Company of Philadelphia, Gerald Francis and Ted Goldsborough of the Lower Merion Historical Society, Erin M. Coté and Jorge Danta of the Philadelphia Historical Commission, Holly Frisbee of the Philadelphia Museum of Art, Ted Pollard of the Radnor Historical Society, Susan Anthony and Ed Zwicker of the Springfield Township Historical Society, Brenda Galloway-Wright of the Temple University Urban Archives, and William Whitacker of the University of Pennsylvania Architectural Archives all helped me locate images and provided research information on various Horace Trumbauer projects. Images from their rich and priceless institutional collections, as well as from the Pennsylvania State Archives, are all represented in this book. In addition, John H. Deming Jr., Richard Marchand, and Robert Morris Skaler all lent images from their personal collections. John Deming and Robert M. Harper also shared their extensive knowledge of the subject with me.

Thanks are also due to my mother, Zelda Hildebrandt, and my sisters, who accompanied me on many research trips and to visit many of the locations featured in this book.

A special word of thanks goes to the Old York Road Historical Society and its board for taking a chance and partnering with me on this project. The society was the largest single source of images for this book, and I was fortunate to have unlimited access to their collections. Joyce Root helped secure the images needed. Finally, I would like to recognize society president David B. Rowland, who provided me with valuable guidance and assistance throughout this entire project.

—Rachel A. Hildebrandt

IN THE NAME AND BY THE AVTHORITY OF THE

COMMONWEALTH OF PENNSYLVANIA

TO ALL TO WHOM THESE PRESENTS SHALL COME, GREETING:

KNOW YE THAT

Horace Trumbauer

of Philadelphia, County of Philadelphia, State of Pennsylvania

HAVING GIVEN SATISFACTORY EVIDENCE OF THE QVALIFICATIONS
REQVIRED BY LAW TO PRACTICE AS AN ARCHITECT IS HEREBY

ADMITTED TO PRACTICE ARCHITECTVRE

IN THE STATE OF PENNSYLVANIA

THIS twenty-sixth day of September, 1921, AND THEREFORE IS A REGISTERED ARCHITECT.

STATE BOARD OF EXAMINERS OF ARCHITECTS

PRESIDENT

SECRETARY

IN WITNESS WHEREOF
THE BOARD OF
EXAMINERS OF
ARCHITECTS ISSVES
THIS CERTIFICATE
NVMBER *497-E.*
VNDER THE SEAL
OF THE STATE.

VIRTVE LIBERTY AND INDEPENDENCE

Horace Trumbauer's architect license is dated September 26, 1921, over 30 years after he started his firm and many years after he left his mark on the architectural world and established his reputation as one of the finest architects in the land.

INTRODUCTION

Horace Trumbauer was born on December 30, 1868, in Philadelphia. His father was Josiah Blyler Trumbauer, a salesman, and his mother was the former Mary Malvina Fable. By the time Trumbauer was 11 years old, his family had moved to the northern suburbs of Philadelphia, where they finally settled in Jenkintown in 1881. He dropped out of school at age 14 to become an office boy at the respected architectural firm of George W. and William D. Hewitt. While working for the Hewitts, Trumbauer gained valuable insights into the process of designing buildings and managing an architectural firm. He also committed himself to a program of self-study wherein he studied the great classical architectural works. His commitment to learning never faded.

In 1890, Trumbauer left the Hewitt firm to establish his own firm in Philadelphia, opening shop at 310 Chestnut Street. In 1898, his office moved to the Land Title Building. Early on, he formed a professional relationship with developer Wendell and Smith. He contributed several designs to two Wendell and Smith projects, Overbrook Farms and Wayne. He also gained the attention of William Welsh Harrison, whose patronage led to significant relationships with other wealthy families in the region, including the allied Widener and Elkins families. To emphasize their wealth, these families built extravagant mansions in Philadelphia's northern suburbs and financed great civic projects through their philanthropic efforts. Trumbauer provided the designs and as a result, gained national recognition and was awarded major commissions.

Trumbauer established his firm during the peak of the American Renaissance in architecture. During this period, which lasted from 1887 until 1917, the classical styles of the Italian Renaissance reigned. Trumbauer skillfully reinterpreted the French styles, the Georgian Revival style, the Tudor Revival style, and the Colonial Revival style. He personally favored the French classical style. As the prevailing styles shifted after World War I, Trumbauer successfully mastered more modern styles, such as the fashionable art deco style. The Chateau Crillon and Jefferson Medical College are evidence of his ability to adapt to changing tastes. It was during this time, too, that his firm produced fewer grand residences and more commercial and institutional buildings. Remarkably, the firm persevered during the Great Depression.

In spite of his success, Trumbauer lived modestly. He married Sarah Thompson Williams on April 25, 1903. He was 34, and she was 42; they had no children, although she had a daughter from her first marriage. They lived in Wynnefield, a Philadelphia neighborhood. He designed his first home but not his second. Trumbauer was also a private man. He never granted an interview, he wrote no articles, and he disliked being photographed. After designing over 1,000 structures, Trumbauer died on September 18, 1938, of cirrhosis of the liver. He is buried at West Laurel Hill Cemetery.

Trumbauer employed many highly skilled architects and designers throughout his career. At its height, his office employed 30 professionals with an office in New York City. Over the years, he had several chief designers, the most well-known today being Julian Abele (1881–1950). Abele, the first African American graduate of the University of Pennsylvania's architecture program, was spotted by Trumbauer shortly after graduation. Trumbauer supported him in his travels to Europe, where he likely studied in an atelier established by the Ecole des Beaux-Arts in Paris. Following his return, Abele joined the Trumbauer firm in 1906. Sometime between 1909 and 1920 (the date is not documented and still debated), Abele became the firm's chief designer, a post he held until Trumbauer's death. He was considered Trumbauer's invaluable assistant and one of the most adept designers of the time. His efforts, along with those of the other architects working in the office, were behind the successes the firm had in producing such major projects as the Philadelphia Museum of Art, the Free Library of Philadelphia's central library building, and Duke University's campus in North Carolina.

After Trumbauer's death, his firm was renamed the Office of Horace Trumbauer/Julian Able, William O. Frank, registered architects. William O. Frank (1887–1968) had joined the Trumbauer firm in 1908, two years after Abele. Frank's son, W. Edward Frank (1911–1991) joined the firm a year before Trumbauer's death. Following the death of Abele in 1950, the firm's name was changed to the Office of Horace Trumbauer, William O. Frank, W. Edward Frank. The younger Frank retired in 1977, and the firm's succession ended.

Trumbauer was a brilliant architect who, from his earliest years in the business, produced superb designs that attracted the attention of many notable personages, a fair number of whom had great wealth. His business success and his lack of a formal education did not endear him to many of his contemporary architects, least of all given that he mastered many styles while they toiled to make a name for themselves in a more limited range. Yet Trumbauer did not seem to be bothered by this. He routinely hired talented people to work for him, stereotypes of the day notwithstanding, and he consistently designed beautiful buildings. In addition, Trumbauer knew his clients and knew what they wanted. While it would be naive to attribute every line to his hand, he clearly was a man in charge of his own firm, the one who stood as the final arbiter of what his clients desired and expected.

Trumbauer made a powerful impact on the architectural landscape, most significantly in and around Philadelphia. However, his reach was not so limited, for he left his mark on the architectural landscape of New York City; Newport, Rhode Island; and the nation's capital. His architectural significance guarantees that he will not be forgotten.

—Rachel A. Hildebrandt

One

PHILADELPHIA'S
NORTHERN SUBURBS

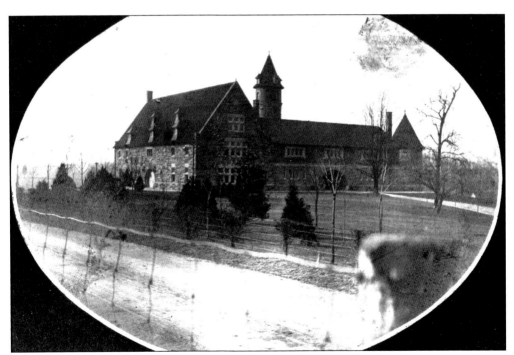

In 1881, William Welsh Harrison, president of the Franklin Sugar Refining Company, purchased J. Thomas Audenried's estate, Rosedale Hall, near Glenside. Harrison asked Horace Trumbauer to renovate and enlarge Rosedale Hall and to design a stable and carriage house complex, a gate lodge, and a power plant. With the exception of the main house, all three outbuildings still stand. Today the stable and carriage house complex is Arcadia University's Murphy Hall, housing art studios, a video production studio, and an auditorium.

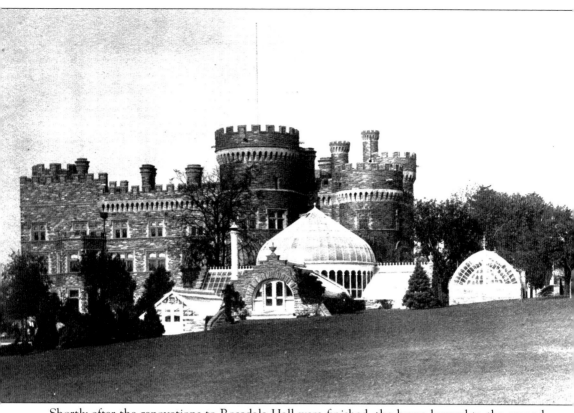

Shortly after the renovations to Rosedale Hall were finished, the home burned to the ground in January 1893. William Welsh Harrison then commissioned Trumbauer to design a far more extravagant dwelling. Trumbauer was all of 24 years of age at the time. Construction on Grey Towers began later that year and was completed in 1896. The interior decorations would not be totally complete for another two years. At the time it was built, the 41-room mansion was considered one of the largest homes in America. The elegant greenhouse, visible in the foreground, stood in contrast to the imposing walls of the castle. The greenhouse was demolished sometime in the 1930s, while the conservatory, attached to the house, was torn down in 1952.

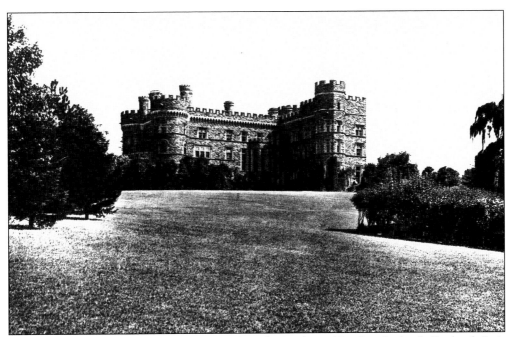

The massive castle is loosely based on Alnwick Castle in Northumberland, England. It is constructed of Wissahickon schist (a gray stone) and features crenellated towers. The building stands today as the central building of Arcadia University's campus.

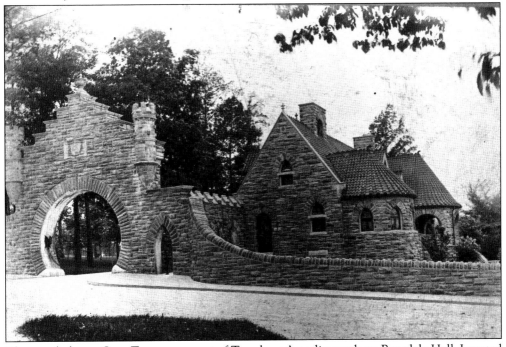

The gate lodge to Grey Towers was part of Trumbauer's earlier work on Rosedale Hall. Located near the point where Easton Road and Limekiln Pike join, the building is now the Blankley Alumni House of Arcadia University. The building's interiors were renovated in 1995, and the exterior stonework was restored in 1998.

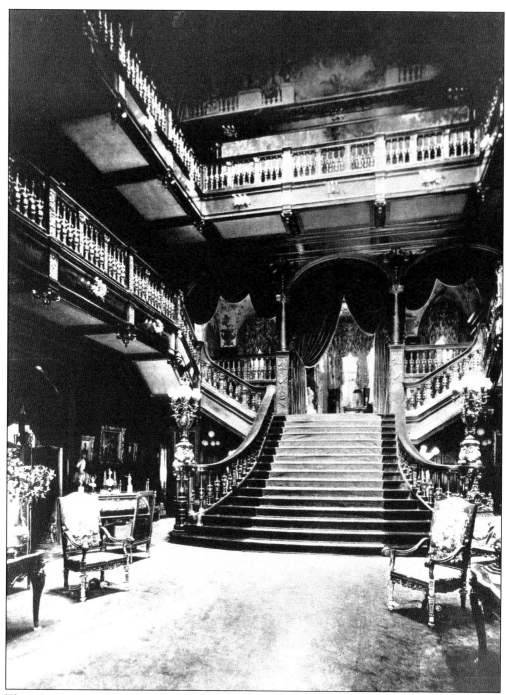

The 41 rooms of Grey Towers were designed by Trumbauer and outfitted by the New York decorating firm of William Baumgarten and Company. The centerpiece and dominant space is the mahogany-lined great hall that rises three stories to a central skylight. The hall contains two matching Caen-stone fireplaces that are based on a fireplace in the Salle de Gardes at the Chateau de Blois in France.

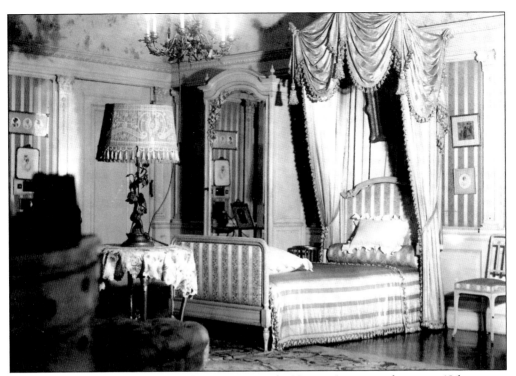

The second floor contained three bedroom suites. Bertha Harrison's suite was done in an 18th-century French style. Her husband and daughter also had suites on the second floor. The Harrisons' son had a suite on the third floor, which also contained smaller bedroom suites for guests.

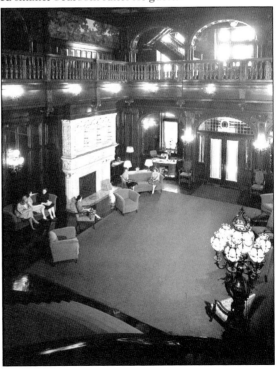

Following William Welsh Harrison's death in 1927, Bertha Harrison sold Grey Towers to Beaver College in 1929. The college, originally from Beaver County in western Pennsylvania, had moved to a campus in Jenkintown in 1925. In 1962, the college consolidated its campus at the Grey Towers site. Until 1972, the school's population was all female. In 2001, the school changed its name to Arcadia University.

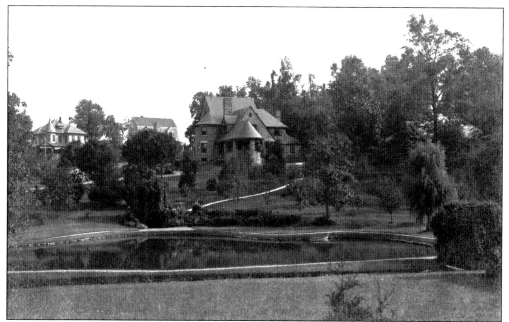

Bend Terrace was built in 1892 for banker Henry K. Walt. The design for this French Normane–style house was first executed in Wayne by builders Wendell and Smith. For Walt, Trumbauer modified the design to fit the landscape. The house still stands at 301 Bent Road in Wyncote. The land between the house and Greenwood Avenue, now Robinson Park, was originally part of the estate.

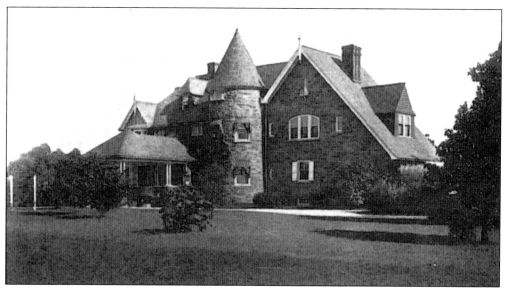

Keewaydin, located at the northeast corner of Church and Accomac Roads in Wyncote, was completed in 1892 for Marian and Frederick Brown of Bethayres. The eclectic house is long and narrow, and it is built of stone with shingles, half-timbering, and stucco. A round tower with a conical roof graces the entrance facade. A large stable behind the house was added in 1900. The property was owned from 1914 to 2008 by members of the Best family. Both the house and stable are extant.

The Beechwood Inn opened in 1878 at the southeast corner of West and Florence Avenues in Jenkintown. The inn served vacationing middle-class families from Philadelphia. In 1894, Trumbauer designed stable and laundry buildings for the inn. The Elizabethan-style stable featured half-timbering, a gambrel roof above the main door, and a hip roof lengthwise. It was demolished in 1984 to make way for an office building.

In 1895, James B. Smith built a store and a carriage shed on Old York Road in Jenkintown. Trumbauer designed both buildings. The modest store, second building from the right, featured a gable roof, a round window on the front pediment, and a small hood over the first floor. The shingle-covered store no longer stands.

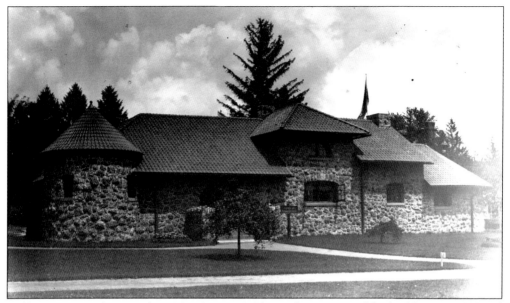

Willow Grove Park opened on May 30, 1896. The park was created by builders Wendell and Smith for the People's Traction Company. Essentially, the park was established to encourage people to ride the trolley line on weekends. The main entrance to Willow Grove Park was on Old York Road where it joins with Easton Road. Trumbauer designed all of the park's primary buildings, including the lodge, which stood adjacent to the entrance. It was the home of the park superintendent. Later the red sandstone building served as a jail and a church before it was razed in the 1950s.

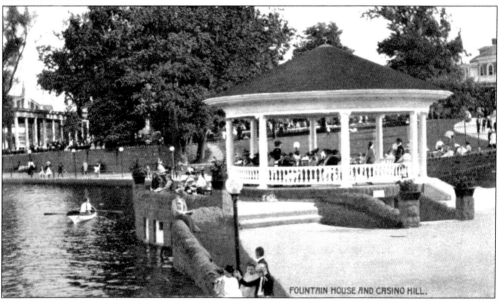

FOUNTAIN HOUSE AND CASINO HILL.

The fountain house stood beside the lake facing the park's famous electric fountain. At street level it served as a pavilion, while underneath it contained the controls that operated the fountain's jets and lights. As the park changed and as the older buildings were demolished, the fountain house stood as a reminder of the park's past glory. However, in 1980, the structure was demolished along with the rest of the park to make way for the Willow Grove Park Mall.

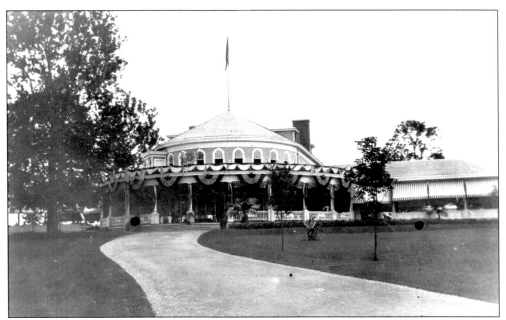

The casino at Willow Grove Park was centrally located on a knoll, thus providing views of the surrounding grounds. The building was intended as the main dining area. Seating up to 550, the casino had 33 waiters during the week with 43 waiters on the weekends. Like all the other buildings in the park, the exterior of the casino was painted a pale yellow with white trim. In 1939, the building was converted into a dance hall. Later it was used for storage until it was destroyed by fire in 1974.

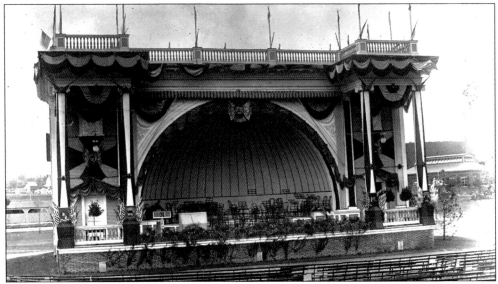

For many, music was the main attraction at Willow Grove Park. Band and orchestra leaders such as John Phillip Sousa, Victor Herbert, Patrick Conway, Arthur Pryor, Guiseppe Creatore, Walter Damrosch, and Frederick Stock performed free public concerts daily during the summer season. The bandstand was considered acoustically perfect when it was first built. A few years later a canopy was built onto the shell to provide cover for concert audiences. The pavilion and shell were demolished in 1959.

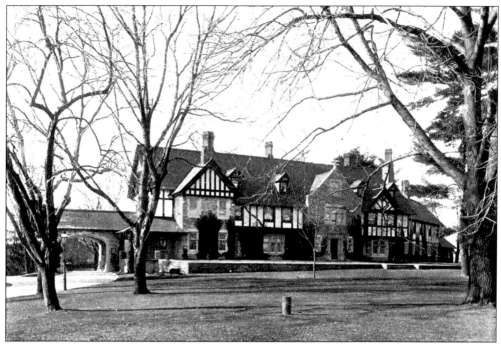

Chelten House was built in 1896 for George W. Elkins, son of traction magnate William L. Elkins, at the southeast corner of Ashbourne Road and Penrose Avenue in Elkins Park. The first floor of the Elizabethan-style house is made of Wissahickon schist with half-timbering above. The facade includes carved limestone grotesques, one of which depicts Trumbauer.

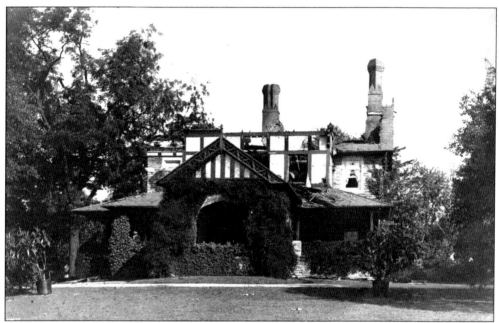

In 1908, a fire destroyed the upper floors of Chelten House. The residence was rebuilt according to the original plans, except the front entrance was replaced by a large bay window. The entrance under the porte cochere at the east end of the house became the principal entrance.

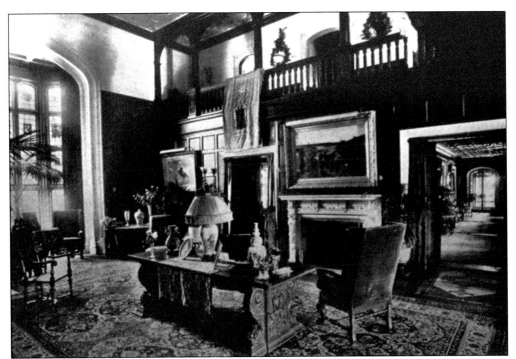

The great hall and the entrance hall (seen through the door to the right) were lined with Tudor paneling. The great hall was converted into a living hall when the front entrance was replaced by a two-story bay window. A reception room, breakfast room, and dining room were also located on the first floor. The second floor contained six bedrooms, and the nursery was located on the third floor.

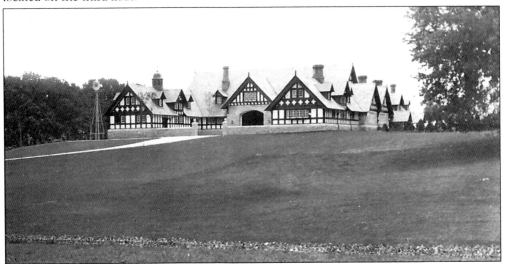

Trumbauer designed a stable complex for Chelten House. Broadly sloping lawns and a pond separate the complex from the rear of the house. The H-shaped stable contained stalls for 12 horses, a carriage house, a cart shed, a harness and cleaning room, a cow barn, a dovecote, machinery and tool houses, and space for the coachmen and grooms. Later Trumbauer also designed a greenhouse complex and a casino for the property. All the buildings still stand, although the property is currently for sale.

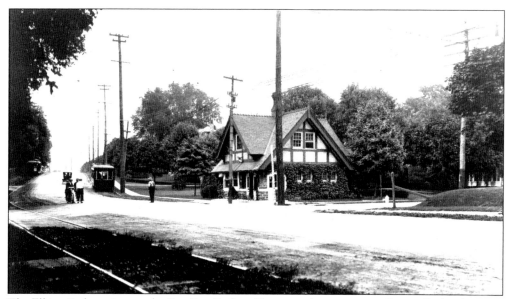

The Elkins Park station on the Reading Railroad line was the gateway to Ogontz Park, a housing development built by William T. B. Roberts. A brochure boasts, "Ogontz Park represents all that is possible in the making of a high class, exclusive residential suburb. There is absolutely no section about Philadelphia to compare with it, either from the standpoint of natural beauty, accessibility, or the quality of its surroundings." One improvement was the construction of an Elizabethan-style tollhouse by Trumbauer for Old York Road. The building was demolished after the turnpike was freed by the state in the years following World War I. Also in 1898, Trumbauer designed a matching house to occupy the corner plot behind the tollhouse that still stands.

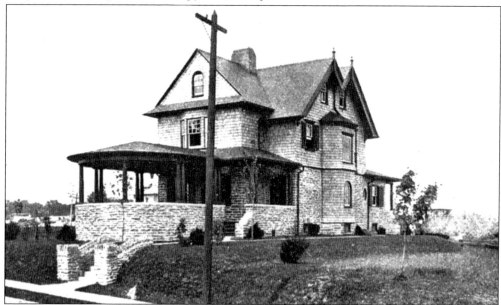

This Ogontz Park house, located at 541 Elkins Avenue, is characterized by a substantial covered porch. According to an Ogontz Park sales brochure, the house "contains 11 rooms, attractive reception hall, pantry, laundry, bath, and store rooms." The first owner, A. M. Friend, named the house Ethel-Bert.

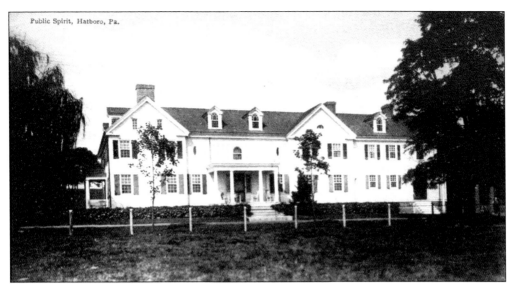

William L. Elkins purchased a farm from the Webster brothers around 1898 in Abington along the east side of Old York Road. Elkins named the enterprise Folly Farm, to reflect his daughter's opinion of the project. He then commissioned Trumbauer to transform the farmhouse into a suitable residence. Trumbauer added a portico and a rear wing to the original building. Inside, he gutted most of the original first floor to create a long room. The grounds have been developed, but the residence still stands at 1500 Marian Road as the rectory for the Church of Our Lady Help of Christians.

The Elkins-Cole House was built atop a hill on Spring Avenue in Elkins Park. It was built in 1898 and was sold in 1906 to wool merchant Charles J. Cole. The Cole family owned the house until 1947. Because the house was the first of many small Georgian Revival–style residences designed by Trumbauer, it is listed on the Pennsylvania Inventory of Historic Places. The house is made of bold orange brick and features a semicircular portico supported by Tuscan columns and pilasters.

23

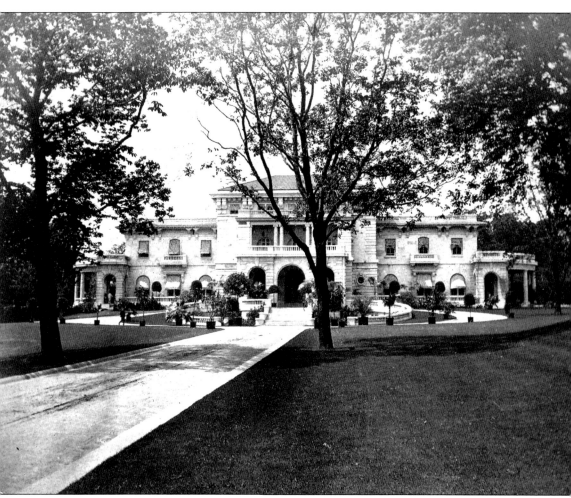

Elstowe was built between 1898 and 1900 for William Lukens Elkins, traction magnate and business partner of P. A. B. Widener. The Italian Renaissance–style house was inspired by the E. C. Benedict mansion in Greenwich, Connecticut (designed by the New York firm Carrère and Hastings), and by the Villa Farnese in Caprarola, Italy. Trumbauer modified the design of the Benedict mansion by shortening the entrance loggia, lessening the number of stairs leading up to the house, and choosing different building materials (granite and limestone rather than brick and stucco). The Dominican Sisters of St. Catherine de Ricci purchased Elstowe in 1932. Seven years later, they acquired Chelten House, which is adjacent to Elstowe. They used the combined property as a retreat center and conducted weekly retreats until June 2007, when they ceased operations. In 2008, the sisters relocated, and the estate awaits a new owner.

The walls of the great hall of Elstowe are of French Caen stone, and the pilasters are of purple Breccia marble. A balcony wraps around the top of the room. The great hall was decorated by Jules Allard et Fils, the Parisian interior design firm that catered to the very wealthy. While the furnishings no longer remain, the architectural integrity of the hall and most of the rest of the house are in a wonderful state of preservation.

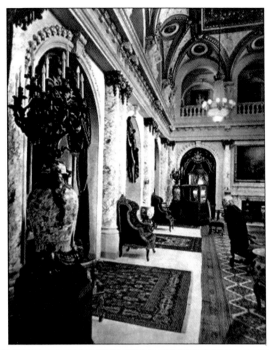

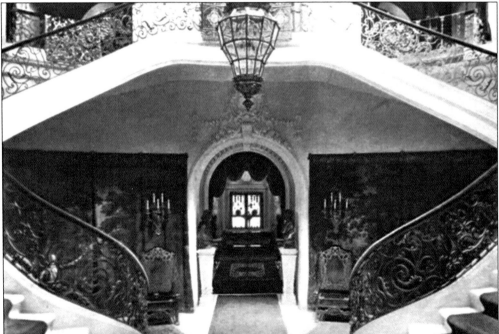

The grand double staircase, located at the center of the house, beyond the great hall, led to a 33-foot-by-48-foot art gallery containing the Elkins family art collection and then to the second floor. The art collection was ultimately given to the Philadelphia Museum of Art by George W. Elkins and his son William M. Elkins. The gallery was converted into the chapel for the Dominican Sisters when they purchased the property. Later they added to the back wing of the house and lengthened the chapel.

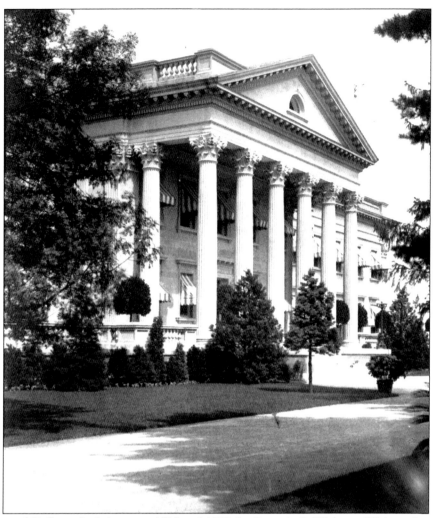

Lynnewood Hall was built between 1898 and 1900 for Peter A. B. Widener. Widener began his career as a butcher. During the Civil War, his connections helped him to secure the contract to supply mutton to all Union soldiers within 10 miles of Philadelphia. After the war, Widener became treasurer of Philadelphia, a lucrative post that he held for a year. Then he began to purchase the streetcar lines in the city. His empire grew, and by the dawn of the 20th century, he controlled the entire network of subways and surface lines in Philadelphia. With partners in New York and elsewhere, he controlled streetcar systems in New York and Chicago. Widener lived in a mansion on North Broad Street and purchased a summer cottage in the Chelten Hills in the 1880s. In 1897, he decided to leave his Broad Street residence and move his family permanently to the Chelten Hills site. The 29-year-old Trumbauer designed a Greek Revival–style mansion that took its inspiration from Prior Park in Bath, England, and Ballingarry (1898–1899), a project he was working on around the same time for Martin Maloney in New Jersey. The facade of Lynnewood Hall features a pediment supported by massive Corinthian columns, and Palladian pavilions grace each side of the long facade. After Widener relocated his family to the new residence, Trumbauer converted Widener's Broad Street mansion into a branch of the Free Library of Philadelphia. At Lynnewood Hall, Trumbauer redesigned the central pediment in 1910, introducing a round window and carved figures. The firm also built an addition on to the art gallery wing of the house.

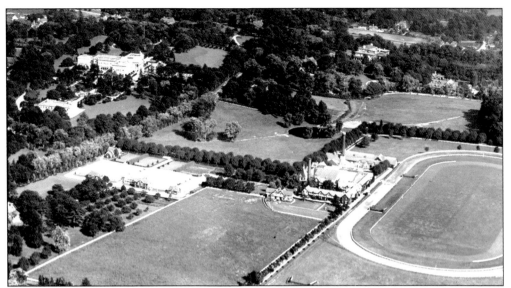

Lynnewood Hall sat in the midst of a 36-acre residential park and across the street from the 117-acre Lynnewood Farm. The farm complex included a garage, greenhouses, a reservoir, stables, a stock barn, a polo field, and a racetrack. In the 1940s, the farm was sold and the grounds were developed into the Lynnewood Garden Apartments.

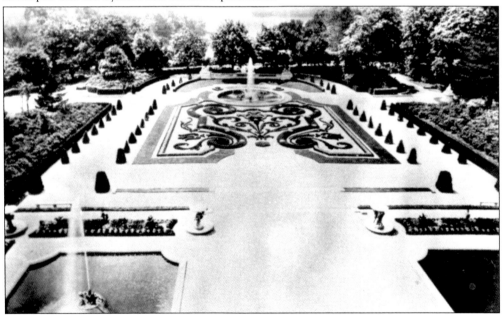

French landscape architect Jacques Gréber (1882–1962) remade the original gardens at Lynnewood Hall around 1916. Gréber was a graduate from the Ecole des Beaux-Arts and came to the United States in 1910 to design the gardens for Clarence H. Mackay's Long Island residence. He returned in 1916 to design the gardens for Edward T. Stotesbury's Whitemarsh Hall and was then hired to design the Benjamin Franklin Parkway. It was during his return to the United States that he likely transformed the gardens for Joseph E. Widener. Gréber filled in the sunken gardens and introduced formal beds and fountains. The ornate center fountain, adorned with tritons and nereids, was designed by Gréber's father, sculptor Henri-Léon Gréber (French, 1855–1941).

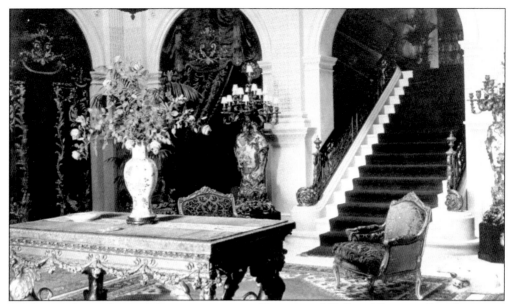

While Trumbauer designed the interior rooms of Lynnewood Hall, it fell to two French interior decorating firms to fill the spaces. Jules Allard and William Baumgarten and Company were the two firms selected to collaborate on the interiors. The great hall was entered from the outside through a set of bronze doors and another set of doors clad in gold. The hall itself rose over two stories to a stained-glass skylight. The central staircase led to the art gallery and the family bedroom suites.

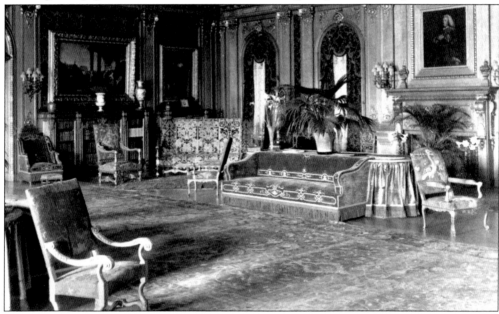

Jules Allard decorated the library/drawing room. The Louis XIV room was the largest on the first floor and was encircled by bookshelves above which hung paintings by Pierre Puvis de Chavannes, Gustave Courbet, de Neuville, Froumentin, and Baron Hendrik Leys. A painting by Giovanni Battista Tiepolo graced the ceiling. Harry Elkins Widener, George D. Widener's son, kept his rare book collection in this room. Following his death aboard the *Titanic* in 1912, the book collection was bequeathed to Harvard University. The room was redecorated as a ballroom.

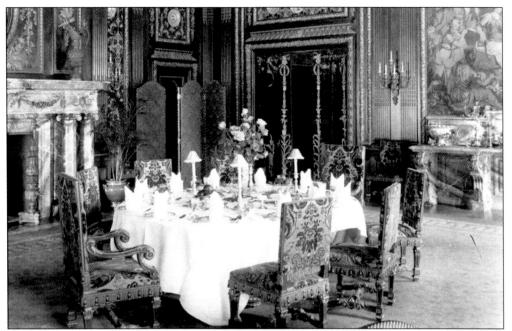

William Baumgarten and Company decorated the dining room. The walls of the walnut-paneled room were accented by gold Louis XIV detailing. The marble mantelpiece and the sideboard were graced by bronze mounts. Red velvet covered the windows. Two Gobelin tapestries hung on the walls. The dining room was remodeled in 1910. The walnut-paneled walls were replaced by green and white marble walls. These walls were stripped from the mansion in the early 1990s, while the building was owned by the financially strapped Faith Theological Seminary.

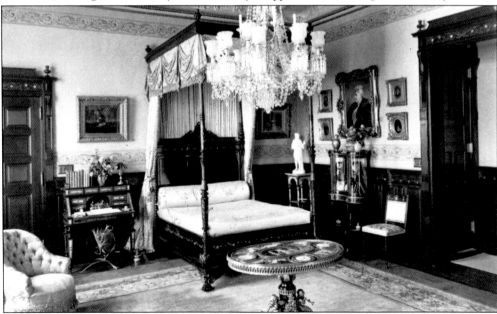

Most of Lynnewood Hall's 18 bedrooms were located on the second floor. The bedrooms were decorated in various styles and filled with fine furniture and elegant fixtures. P. A. B. Widener's bedroom was located in the east wing of the house. A portrait of his late wife hung on the wall.

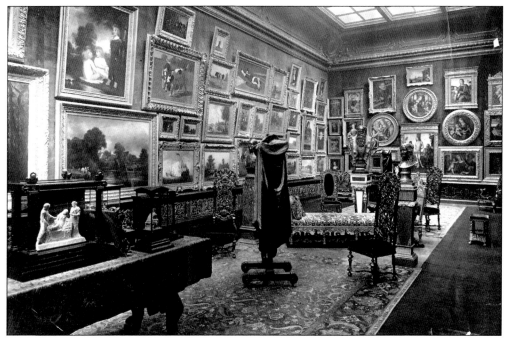

P. A. B. Widener's original art gallery ran 90 feet down the center of the rear wing of the house. As was the style of the day, the paintings were hung from floor to ceiling. The collection included over 500 paintings.

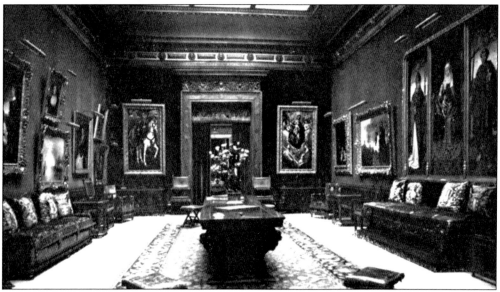

Following his brother George's death in 1912, Joseph E. Widener took over management of the family's affairs, including the art collection. He began to refine the art collection, drastically reducing the number of paintings and remodeling the gallery, dividing it into two rooms. One gallery contained artwork by El Greco, Thomas Gainsborough, George Romney, and Titian, while the second housed works by Rembrandt and Johannes Vermeer. Joseph allowed the public to enjoy the galleries from June to October each year. The Widener collection of paintings and decorative arts was donated to the National Gallery of Art in Washington, D.C., in the early 1940s.

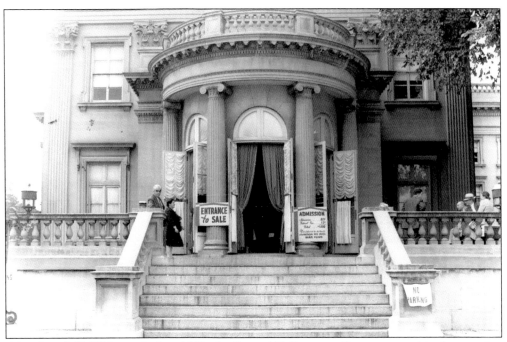

After Joseph E. Widener died in 1943, the Samuel T. Freeman Company was hired to auction off the mansion's contents. Admission to the sale cost $1, and the money was donated to the American Red Cross War Fund. The mansion and farm were sold; both parcels eventually were purchased by the Robinson family. They maintained the mansion until 1952, when they sold the 36-acre residential site to Carl McIntyre's Faith Theological Seminary.

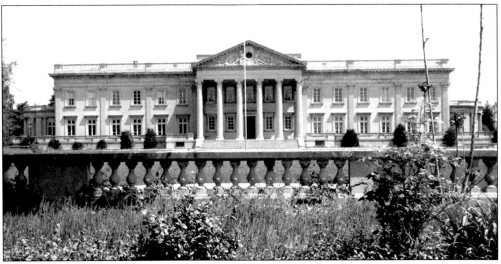

Faith Theological Seminary owned Lynnewood Hall for over 40 years. As the seminary failed to keep up with the cost of maintenance, it sold off various pieces of garden statuary. Matters took a turn for the worse in the early 1990s when many savings and loan banks failed, including one that held a mortgage on the seminary property. After several short-term property holders with seminary affiliations, the site was eventually purchased in 1996 by Dr. Richard Yoon, a former member of the seminary board. His First Korean Church of New York Inc. is the present owner of the property.

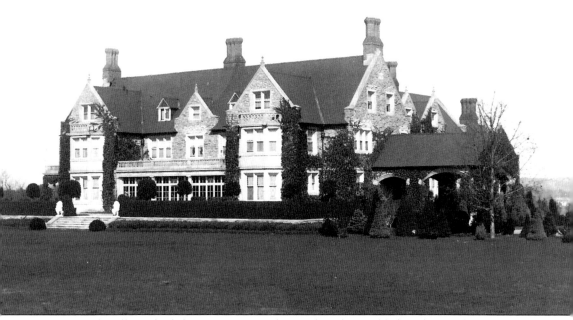

St. Austel Hall was built between 1899 and 1900 for John Gribbel at the northwest corner of Church and Rices Mill Roads in Wyncote. Trumbauer based the mansion's design on an English manor, Kelmscott House, which was home to the English craftsman William Morris. Gribbel began his career in the banking business in New York City in 1876. In 1883, he became the New York agent for Harris, Griffin and Company, manufacturers of gas meters. In 1890, he entered into partnership with the company's owner, John J. Griffin, and moved to Philadelphia. Following Griffin's death in 1892, Gribbel became sole proprietor of the concern, which later became the America Gas Meter Company. Gribbel was a director of the Curtis Publishing Company and, in 1913 with Curtis, purchased the Public Ledger Company, publishers of one of Philadelphia's largest independent newspapers. Gribbel remained a considerable influence in Philadelphia and New York banking circles throughout his life, serving as a director for several banks. In addition, he was either director or president of a number of oil and gas concerns located throughout the country. Gribbel was a renowned collector and had a valuable collection of American Colonial historical documents and autograph letters, English and French engravings, and rare books. His most famous purchase was of the Glenriddell manuscripts, the largest collection of manuscripts in existence by the Scottish poet John Burns, which he gave to the people of Scotland.

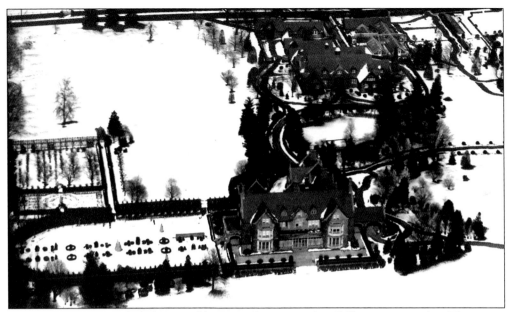

The 42-acre estate included two stables, greenhouses, and a 1905 garage complex. The estate was complimented by finely manicured formal gardens on the west side of the house. While the gardener's cottage on Royal Avenue survives, the remainder of the site was cleared in the early 1950s to make way for a housing development.

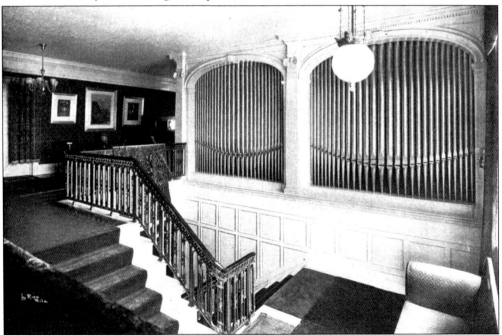

St. Austel Hall was built by George F. Payne and Company of Philadelphia. The house and stable cost $74,000 to construct. The interior was done with handsomely fitted hardwoods and tiles. The rooms on the main floor included a music room, gallery hall, library, billiard room, dining room, breakfast room, and an alcove and organ chamber. The organ was manufactured and installed by the Aeolian Company of New York in a chamber that extended up the center stairwell.

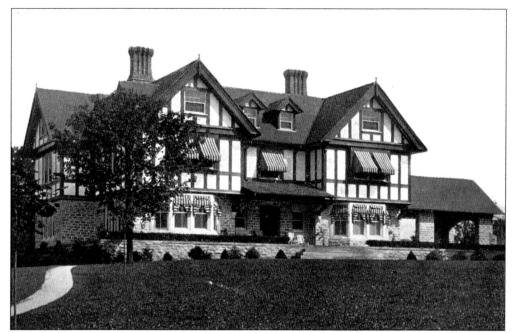

Wyndhurst was built between 1899 and 1900 for John Milton Colton, a member of the Philadelphia banking firm of E. W. Clark and Company. Colton had previously used Trumbauer in 1892 to alter a residence that he had purchased from J. Elwood Peters. Wyndhurst stood on Old York Road just north of Rydal Road in Jenkintown.

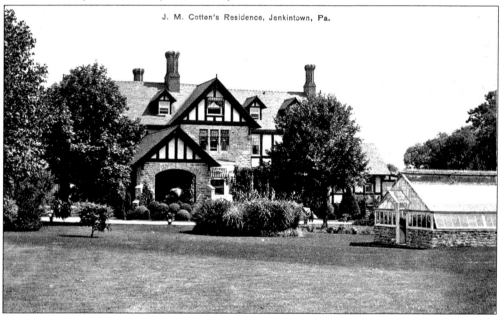

The Elizabethan-style mansion featured a low terrace, a first floor made of stone, half-timbering above, and complex brick chimneys. Upon Colton's death in 1913, most of his estate was bequeathed to charities. His will provided for the establishment and construction of the Abington YMCA. The mansion was demolished in 1931 to make way for the second suburban Strawbridge and Clothier department store, the first located in Ardmore.

34

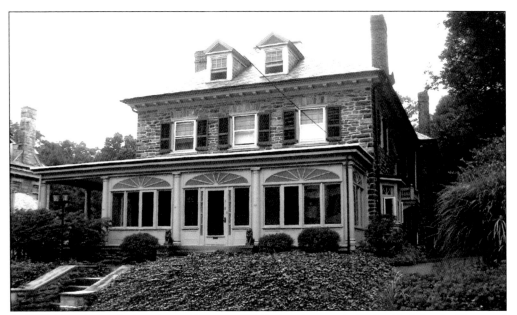

In 1899, Trumbauer designed a residence at 518 Spring Avenue in Elkins Park for the Reverend Edward W. Appleton, recently retired rector of St. Paul's Episcopal Church. Two wealthy members of his congregation paid for the Spring Avenue home so that Appleton would leave the rectory. The Georgian Revival–style house is made of Wissahickon schist and is topped by a slate roof. It features a porch and tall chimneys. The second owner, George L. Adams, had Trumbauer design an adjoining stable in 1904. Later modifications were made, although not by Trumbauer.

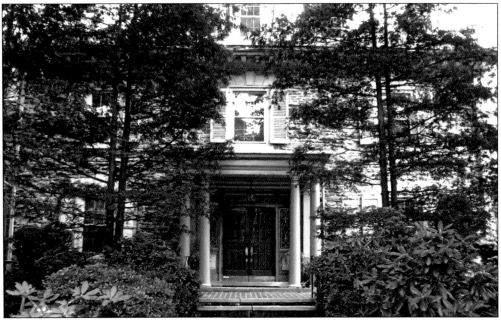

The residence of Charles Schmidt was built in 1904 at 7837 Old York Road in Elkins Park. The Georgian Revival–style house is of stone and features a portico, a front door surrounded by elegant glass panels, windows with shutters, dormers, and brick chimneys. It is now the Manor Professional Building.

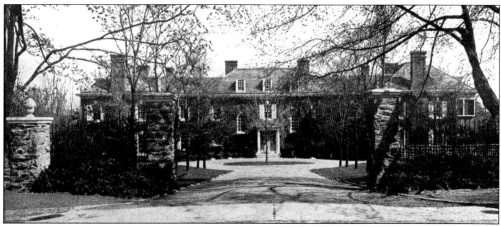

Georgian Terrace was built in 1905 for Stella Elkins and George F. Tyler. The brick Georgian Revival manor was a wedding gift from Stella's father, George W. Elkins. In the early 1930s, she donated the house to Temple University to be used as an art school. She chose her former art teacher, Boris Blai, to head the school. The Tyler School of Art relocated to Temple's main campus in the spring of 2009. The university reports that there are no plans for the Elkins Park campus, although it will continue to maintain the property.

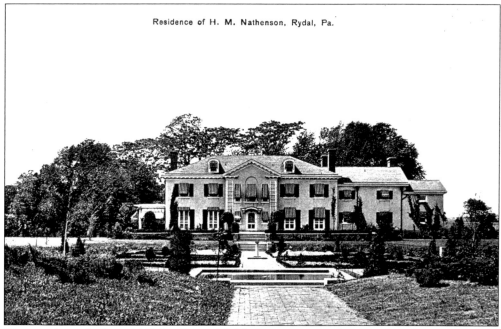

Residence of H. M. Nathenson, Rydal, Pa.

Westwood was built in 1907 for Henry M. Nathanson, general manager and member of the department store chain N. Snellenburg and Company. The estate was located on Mill Road at the corner of Susquehanna Road in Rydal. The Georgian Revival–style home featured two terraces that elevated the house above the surrounding grounds. Trumbauer designed a twin farmhouse, stable, and chicken house for the estate. About 50 years after the house was built, it was demolished to make way for a housing development.

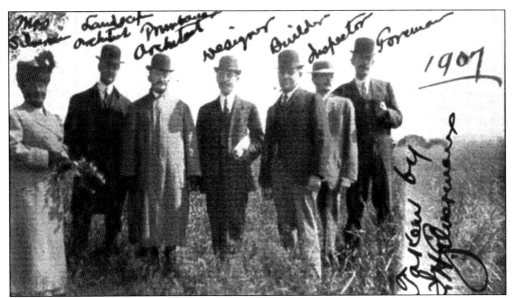

In 1907, Ida H. Silverman hired Trumbauer to design a home for his family next to Nathanson's Westwood. Silverman was partner in an electrical engineering firm and president of a street railway company. This rare photograph captures (from left to right) Mrs. Silverman, the landscape architect, Trumbauer, his designer, the builder (likely D. W. Sperry), the inspector, and the foreman on the estate's grounds.

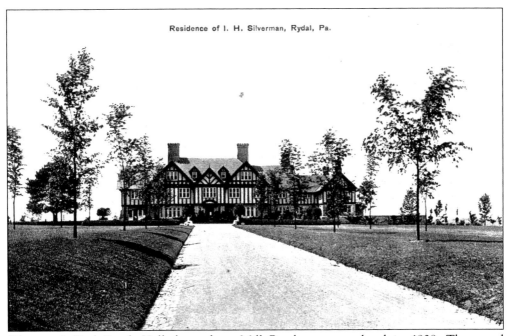

Silverman's Paul Brook Hall, located on Mill Road, was completed in 1908. The grand Elizabethan-style home contained a library, music room, billiards room, and a servants' wing on the first floor and nine bedrooms on the second floor. Like Westwood, it was demolished to make way for new housing. The stable and another outbuilding remain as private residences.

In 1910, Trumbauer designed four homes for the Cadwalader Estates development located in Elkins Park on Cadwalader Avenue and the adjacent streets between Church and Township Line Roads. The Colonial Revival–style home (above) is located at 8110 Cadwalader Avenue. C. A. Jayne was the first owner. The symmetrical home of stone, half-timbering, and stucco (below) is located at 8128 Brookside Road.

This house was built between 1910 and 1911 for Charles James Matthews at 105 Prospect Avenue in Langhorne, Bucks County. Matthews was a leather manufacturer, and his factories were located at 119 North Fourth Street and 430 North American Street in Philadelphia. The first floor contains a reception room, a living room, and a dining room. The second floor contains six bedrooms and a dressing room arranged around the hall. This house is extant.

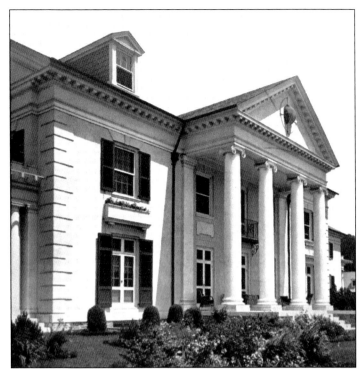

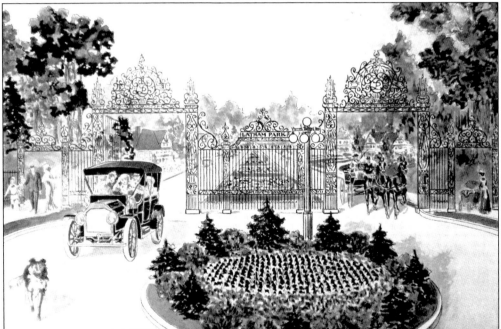

The exclusive development of Latham Park on Old York Road near the city line is located on the former site of Roadside, the home of abolitionist Lucretia Mott. Latham Park's 28 acres were owned by George W. Elkins and were developed by William T. B. Roberts in 1912. This illustration from the development's promotional brochure highlights the ornate gate that Trumbauer designed. Trumbauer did not design any of the community's houses. The gateway and fence are extant.

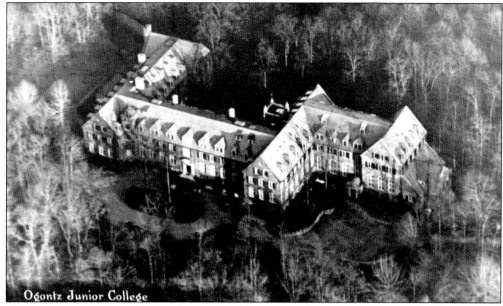

Ogontz Junior College

The Ogontz School for Girls was founded in 1850 as the Chestnut Street Female Seminary. The school was originally located in Center City. In 1883, it moved to Jay Cooke's estate, Ogontz, and as a result, the school changed its name. In 1917, under the direction of headmistress and owner Abby Sutherland, the Ogontz School moved to Abington and sold the Ogontz property to the Widener family, who built Ronaele on the site. For the Ogontz School, Trumbauer designed a Georgian Revival–style building, now called Sutherland Hall, which housed classrooms and dormitories.

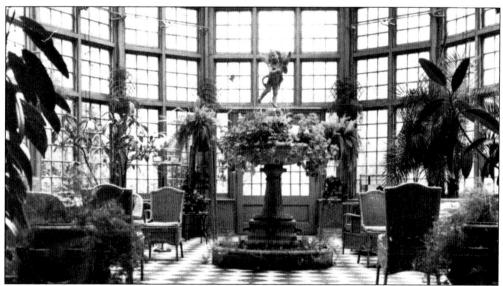

In his design for Sutherland Hall, Trumbauer included a conservatory that resembled the conservatory at Ogontz. It is located at the rear of the building, opposite the main entrance. Over the years, Trumbauer would design several other buildings for the school. In 1950, the Ogontz School closed, and Sutherland gave the property to the Pennsylvania State University. Sutherland Hall still stands as part of the Penn State Abington campus.

In 1923, Trumbauer modified the William S. Peace residence on Hampton Road in Rydal. In addition, he added a combined stable and garage. The house and garage still stand.

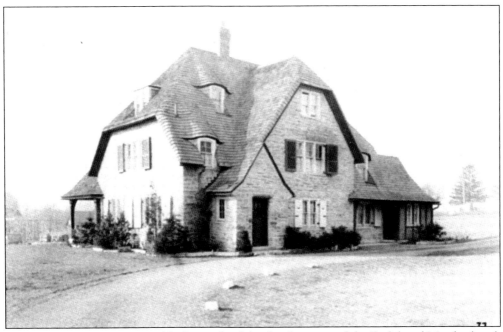

Wayne Herkness was responsible for much of the development of the Rydal and Meadowbrook areas. In 1922, he hired Trumbauer to design a house at the southwest corner of Woodland Road and Cloverly Lane. Harry S. Ambler was the first occupant and Roland D. Porter was the second. The house still stands.

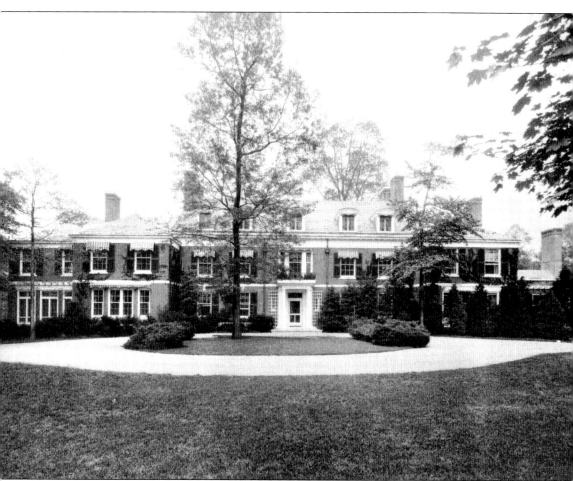

In 1923, Trumbauer designed a house for Cyrus H. K. Curtis, founder of the Curtis Publishing Company. It was a gift to his stepdaughter and her new husband, John C. Martin. Located at the northeast corner of Church Road and Greenwood Avenue in Wyncote, the enormous Georgian Revival–style brick mansion was built by Doyle and Company. Originally named Wedgewood, the mansion was sold in the late 1940s and, for eight years, was the Norte Dame High School for girls. In 1955, the Ritter Finance Company purchased the property and constructed a large addition on the back of the residence. The Reconstructionist Rabbinical College, founded in 1968, has owned and occupied the building since 1982.

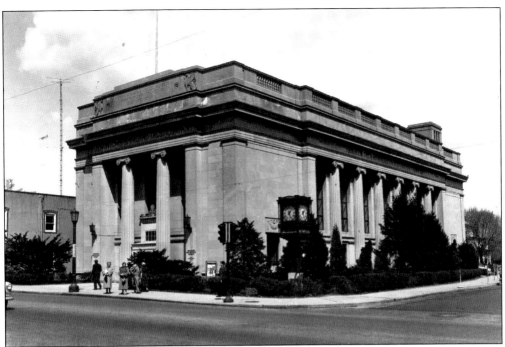

The Jenkintown Bank and Trust Company building was erected between 1924 and 1925 at the northeast corner of Old York Road and West Avenue. The institution was formed in 1922 when the Jenkintown National Bank and the Jenkintown Trust Company merged. Howard Fleck was the new bank's first president. Today the building retains its original function as a Wachovia Bank branch.

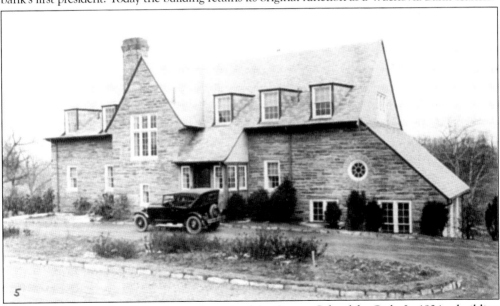

The Rydal Country Day School was a branch of the Ogontz School for Girls. In 1924, a building for the school was erected on the grounds of the Ogontz School in Abington. The Tudor-style building is made of stone and features a large window and a brick chimney at center, a row of dormers, and a wing topped by a steeply sloping slate roof. The building still stands on the Penn State Abington campus.

43

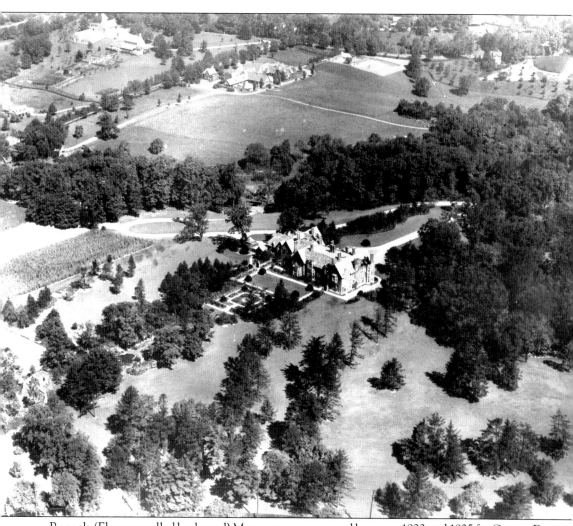

Ronaele (Eleanor spelled backward) Manor was constructed between 1923 and 1925 for George D. Widener's daughter Eleanor Widener and her husband, Fitz Eugene Dixon. The Widener-Dixon wedding, which occurred two weeks after the bride's father and brother perished on the *Titanic*, was held at Lynnewood Hall. Ronaele Manor was built on the site of Jay Cooke's estate Ogontz and was surrounded by 114 acres that included several Trumbauer-designed outbuildings. In 1950, Eleanor Dixon sold the property to the Christian Brothers of LaSalle College. The Brothers renamed the mansion Anselm Hall and used the building to house student-Brothers in the Philadelphia area. In 1973, they sold the estate to developers, but not before removing several interior features of the home that were relocated to the LaSalle University Art Museum. The neighbors successfully fought the proposed housing development for a time, but the main house was demolished in October 1974 and the land subsequently developed. Many of the estate's outbuildings still remain.

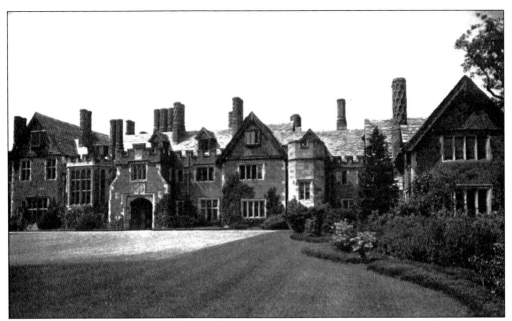

Ronaele was based on Compton Wynyates, a 15th-century masterpiece located in Warwickshire, England. The Tudor Revival–style home was of colored brick with a limestone facade featuring the Dixon family crest and motto, "Fortune Favors the Bold," above the entrance. The picturesque house was topped by a slate roof and boasted 28 chimneys that featured different brickwork motifs.

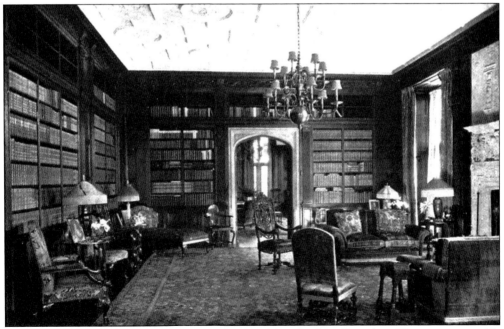

Ronaele contained 50 rooms. Most were decorated by Charles of London. The rooms resemble the rooms of Rough Point, the Newport, Rhode Island, mansion that Trumbauer transformed for James B. Duke in 1922. Ronaele's English Renaissance–style library, located at the southwest corner of the first floor, featured antique panels.

Trumbauer designed a residence for Abby Sutherland on the grounds of the Ogontz School in 1926. The residence, named Lares, is identical to the J. Clayton Strawbridge residence in Merion (1922) and the Henry D. M. Weir residence in Glenside (1926). The Tudor dwelling is of stone and features many windows and a prominent brick chimney. The building still stands (although it has been modified) on the Penn State Abington campus and is known as Lares Hall.

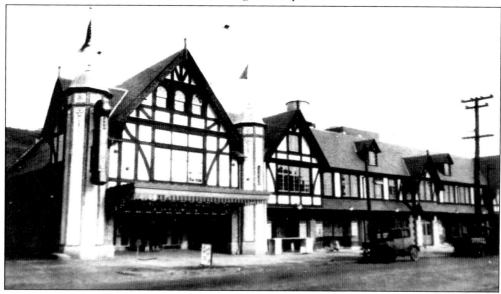

The Keswick Theatre in Glenside was built in 1928 for Edwin Johnson and opened just as film was replacing vaudeville. The Elizabethan-style theater and the attached stores and offices were built by the Turner Construction Company. The theater's half-timbered facade is topped by a slate roof. The theater went bankrupt in the 1930s, suffered a fire in 1952 that left it closed for several years, and was in danger of being demolished in the 1980s. It was saved by the Glenside Landmarks Society, before private owners were found. The facade of the building was restored in 1994. The Keswick Theatre, which is now an AEG Live venue, continues to host concerts and shows.

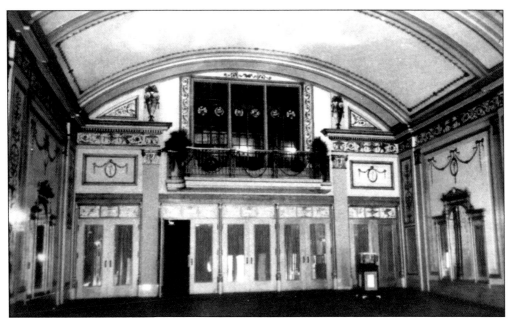

The lobby is a fusion of the Adams and Elizabethan styles. It contained decorative tile, mirrors, windows, and plasterwork. The Moravian tile is from the historic Moravian Tile Works of Bucks County. Many of the architectural details have been hidden by alterations.

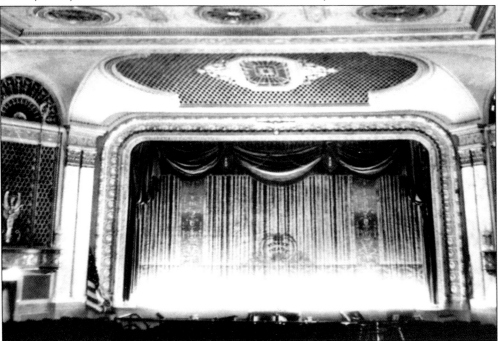

The Keswick Theatre's elegant auditorium was embellished with glass panels, and the walls were lined with fabric. The floor is sloped to provide every patron with an uninterrupted view of the stage. Fresh air flowed from tunnels underneath the aisles, and "magic mushrooms" fed air into the auditorium. During the summer, the tunnels were filled with ice over which fans circulated the air. Today much of the original decoration remains covered, awaiting restoration.

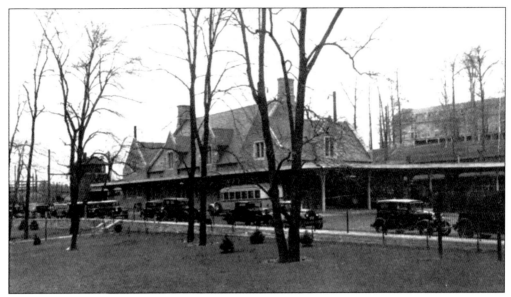

The Jenkintown station stop on the Reading Railroad went into service in 1859. A station building was constructed in 1872. When the train lines were electrified in 1931, the railroad commissioned Trumbauer to design a new building. Completed in 1932, the Tudor-style station is constructed of Wissahickon schist. The Jenkintown train station remains in use today, and its interior spaces are occupied by a local restaurant.

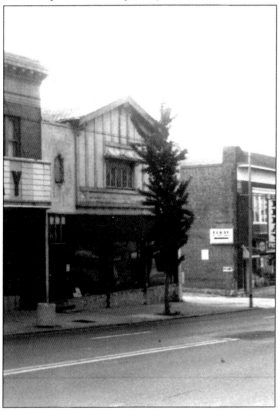

Designed in 1932 as an automobile showroom/service building for William Hippsley, this building features three large windows at street level and half-timbering above. To the left and right of the window on the second floor are tiled nooks that once contained urns guarded by balconies. The building, located at 208 Old York Road in Jenkintown, still stands and is home to the Jenkintown Antique Guild.

Two

THE MAIN LINE

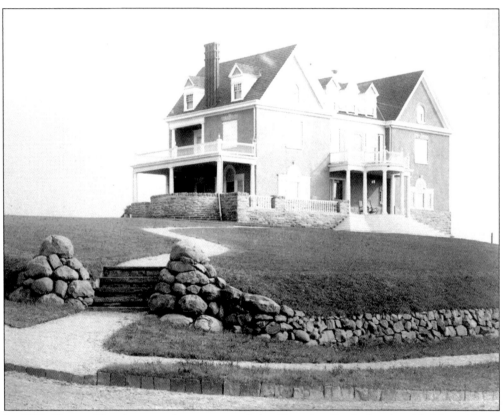

In 1891, Horace Trumbauer took steps toward the Georgian Revival style with his residence for Joseph B. Seybert. The symmetrical house featured an elevated main entrance and a porte cochere supported by Tuscan columns. The house burned down, and two smaller houses occupy the site on St. Davids Road in St. Davids.

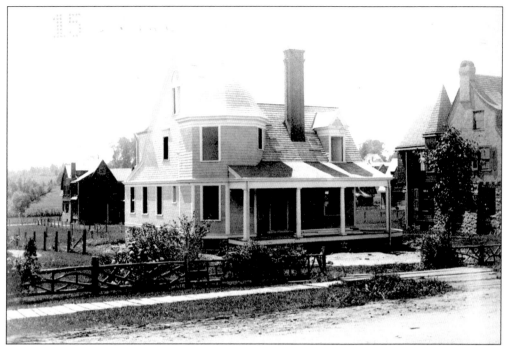

One of Trumbauer's first major patrons was the development and construction firm of Wendell and Smith. In 1891, Trumbauer produced a design that the firm used for two homes, one in South Wayne on Beechtree Lane (pictured) and the other on Chestnut Lane south of Eagle Road in North Wayne. Both are still standing. Because the plans were published, several copies of the house appeared throughout the area.

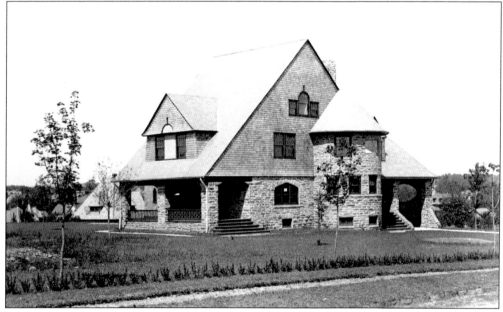

In 1892, Trumbauer produced additional designs for Wendell and Smith. This Queen Anne, still standing at 314 Louella Avenue in Wayne, is of stone and shingles and features a tower with a conical roof.

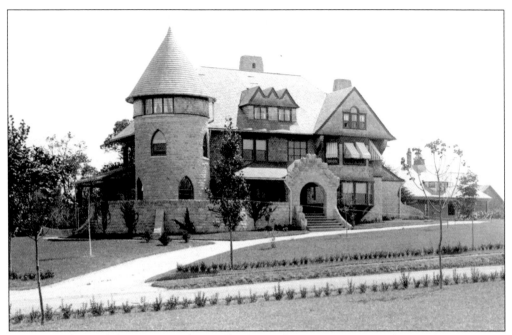

Trumbauer designed the Wayne residence of banker William Watts in 1892. The stone house sits atop a terrace supported by buttresses. The entrance is crested by cat steps, and a double dormer protrudes from the roof. Gothic windows and a conical roof grace the tower. The house is still standing.

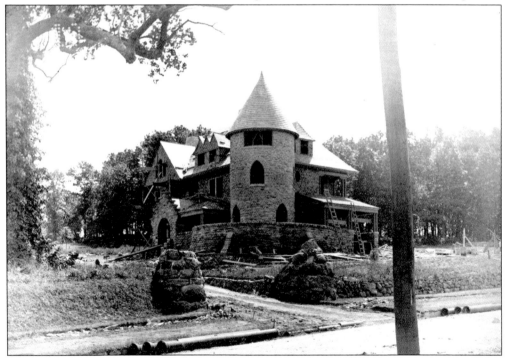

The 1893-dated residence of Charles S. Walton in Wayne, shown during construction, included a main hall, a dining room, a parlor, a library, and service rooms. Four bedrooms and a bathroom were on the second and third floors. The residence is no longer extant.

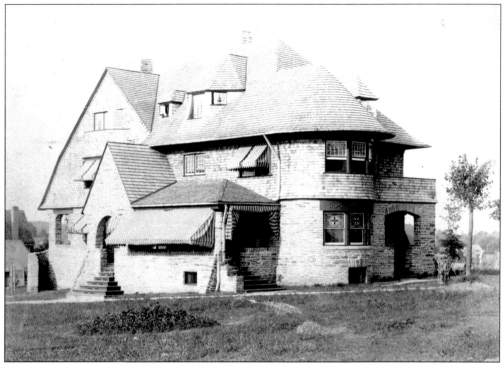

The residence of Frederick H. Treat was located at the corner of Louella Avenue and Upland Way in Wayne. The c. 1892 house featured two distinct facades, one faced Louella Avenue (above), and the other faced Upland Way (below). The first floor was of stone, and the upper floors were covered in shingles. The design for this house was reused in Jenkintown for Emma G. Schwartz. Neither house survives.

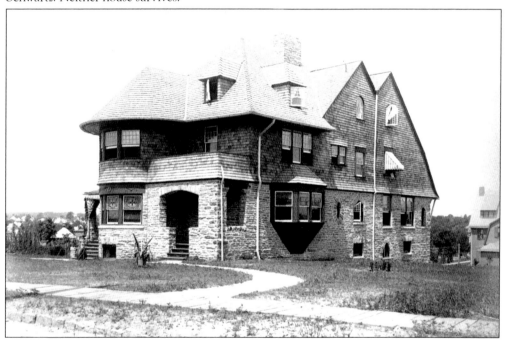

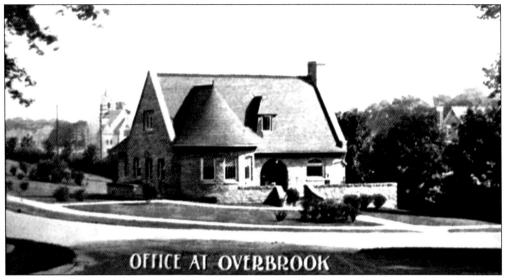

OFFICE AT OVERBROOK

The Overbrook Farms development was conceived in 1892 when Drexel and Company purchased the John M. George Estate. Drexel then hired the development firm Wendell and Smith, which in turn commissioned prominent architects (including Charles Barton Keen, Walter F. Price, and Angus Wade) to design homes that were built on spec. The Overbrook Farms office of Wendell and Smith was built in 1893 in the neo-Romanesque style. The unique structure showcased the many different types of doors and windows available to the prospective home buyers in the development. The building, which stands adjacent to the Overbrook train station, is now a private residence. The Overbrook Farms community was added to the National Register of Historic Places in 1985.

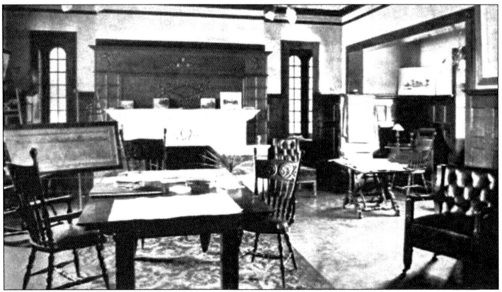

The reception room of the Wendell and Smith office at Overbrook Farms was dominated by a large stone fireplace. In the reception room, Wendell and Smith met with prospective home buyers. They believed "American men work hard, and when they rest, they want restful surroundings. . . . Those who are cooped up in their offices all day want an evening in the country, away from the . . . feverish unrest of the city, to give them strength for the next day's battle."

53

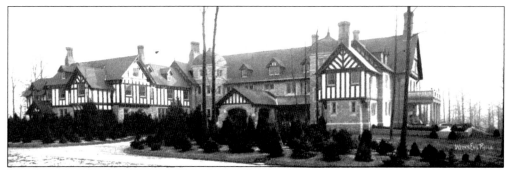

Woodcrest was built between 1899 and 1900 for James W. Paul Jr., a partner in the prestigious banking firm of Drexel and Company. The Elizabethan-style mansion is made of rough Wissahickon schist and trimmed in limestone. The second and third floors are half-timbered. The gardens were designed by Paul's nephew, landscape architect Oglesby Paul (1876–1915). After Paul's death in 1908, members of his family continued to reside at Woodcrest until the early 1920s, when the estate was purchased by Dr. John T. Dorrance. In 1899, Dorrance invented the formula for condensed soup. In 1914, he became president of the Campbell Soup Company and a year later became its sole owner. The Dorrances lived in the Radnor mansion until 1953. Cabrini College, founded in 1957 by the Missionary Sisters of the Sacred Heart of Jesus, ultimately purchased the estate. The mansion, dedicated in 1969 as Woodcrest Hall, contains administrative offices.

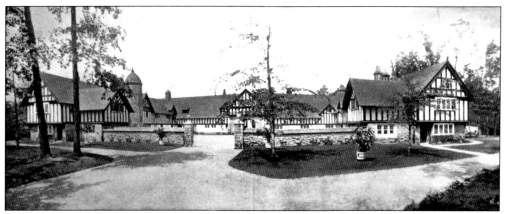

The outbuildings on Woodcrest's 230 acres were also designed by Trumbauer. The half-timbered carriage house and stable complex housed the staff and 60 horses. Today it contains faculty and administrative offices. The courtyard was enclosed in 1990 to create an atrium and a conference center.

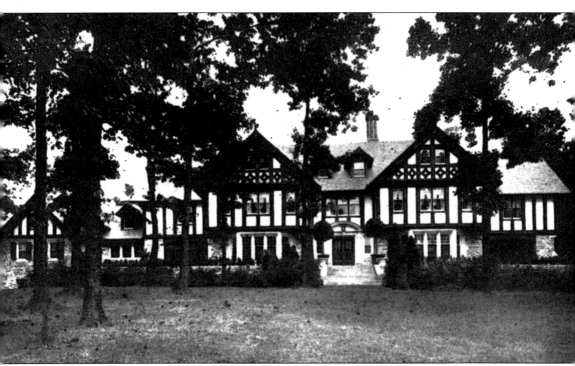

Oatlands, the Devon residence of financier C. Hartman Kuhn, was built between 1904 and 1905. The Tudor-style house was made of stone and featured half-timbered upper floors. The estate included a stable and a gardener's cottage that were both designed by Trumbauer. In 1907, the architect added a garage. Kuhn was a director of the Girard Trust Company and the Insurance Company of North America. He was an art patron and involved in musical circles in Philadelphia and New York City. He was a charter member of the Philadelphia Orchestra Board of Directors. Annually the C. Hartman Kuhn Award is presented to an orchestra member "who has shown ability and enterprise of such character as to enhance the standards and the reputation of The Philadelphia Orchestra." In 1955, the property became the Regina Mundi Priory. Hill Custom Homes demolished the residence in 2002 to make way for a housing development. The carriage house was saved and is a private residence.

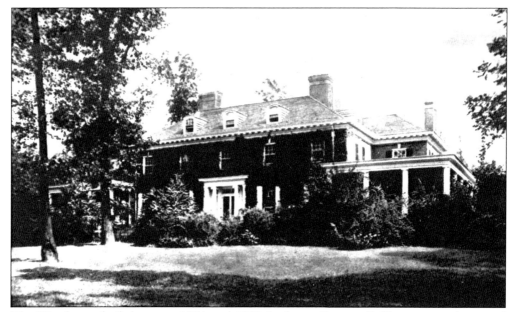

The Woods was built between 1904 and 1906 for James Frances Sullivan, a merchant and the director of several street railways. For years, the brick Georgian Revival–style house was covered by vegetation, and the wood porches were shaded by bushes. The mansion still stands in Radnor, surrounded by a housing development. The extant stable has been converted into a private residence.

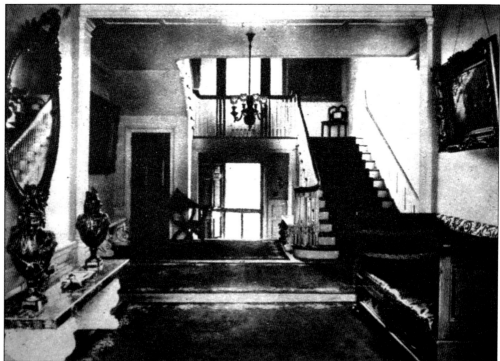

The main entrance hall and stairway of the Woods was done in a simple Georgian style. After the interiors of the house were damaged by fire in the early 1920s, they were redesigned.

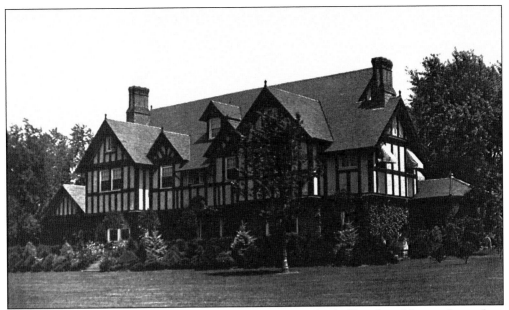

Penn Ivy was built in 1905 for William N. Steigerwalt. The half-timbered house, located on Highland Avenue in Merion, was constructed by builder Elmendorf J. Hedden. Following a fire in 1914, Trumbauer revised his original plans when the home was rebuilt. The Elizabethan-style house no longer stands.

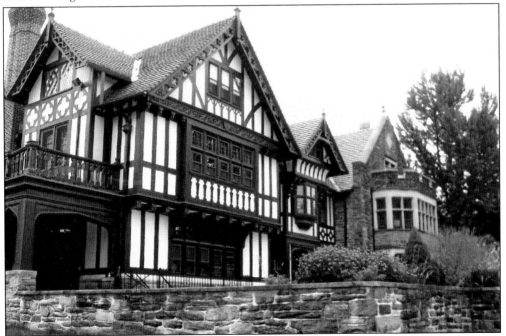

Located at 1344 Montgomery Avenue in Rosemont, the residence of Henry Swope Kerbaugh was built between 1905 and 1906. Kerbaugh was a contractor and is best known for building the Kensico Dam in Valhalla, New York. The mansion contains 19 rooms and features leaded-glass windows throughout. The Tudor-style mansion became the Rosemont School of the Holy Child in 1949 and still stands on the Catholic school's campus.

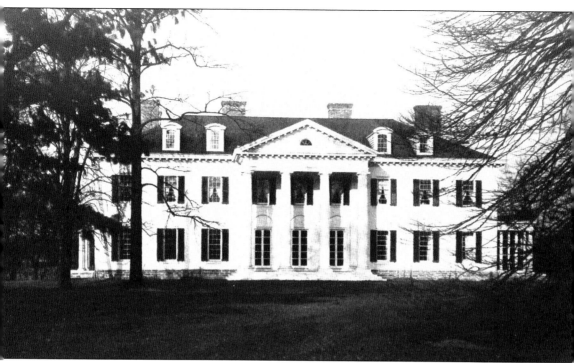

Edgar C. Scott inherited the Scott family's summer home in Darby Borough in 1901. Edgar was a son of Thomas A. Scott, president of the Pennsylvania Railroad from 1874 until his death in 1881. For a time, the company was the largest corporation in the world. Edgar hired Trumbauer to rework the Victorian house into the mansion that still stands. The 55-room residence, known as Woodburne, brings together the American Federal and Greek Revival styles. The building includes a huge service wing that contained quarters for the male servants, 11 maids' rooms, and a dining room for the staff. Today the home is the Villa St. Teresa.

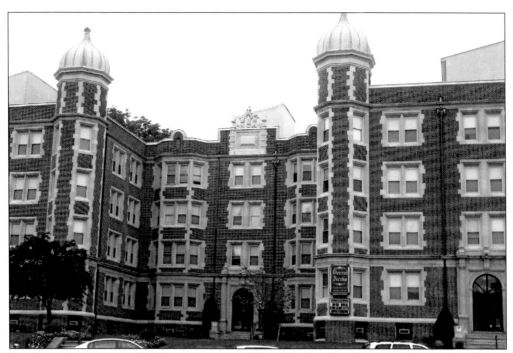

The Drexel Apartment Building, located at 6301–6311 Overbrook Avenue in Overbrook, was built in 1909. Builder J. B. McHugh erected the Jacobean-style apartment building, now called the Drexel Arms, that today houses students from St. Joseph's University.

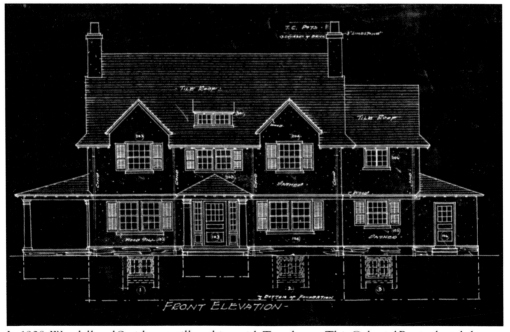

In 1908, Wendell and Smith was still working with Trumbauer. This Colonial Revival–style house, "House #7 for Wendell & Smith," was a later design for the Overbrook Farms development.

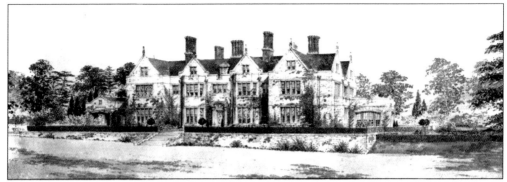

Coolkenny, located on Montgomery Avenue in Haverford, was built in 1909 for Thomas P. Hunter. An immigrant from Ireland, Hunter started in business with a small store in 1885 at the age of 25 with $600 in capital, half of which was borrowed. Two years later, he formed the Acme Tea Company. The enterprise grew into a large chain of grocery stores in Pennsylvania and New Jersey. At the time of Hunter's death in 1915, there were more than 400 stores. In 1917, his business partners merged the company, along with four other chain stores, into the American Stores Company, which later became Acme Markets. The Elizabethan-style house was made of Wissahickon schist and accented with limestone. According to a 1937 advertisement, the mansion was "conceived and developed by an indulgent spirit with utter disregard to cost."

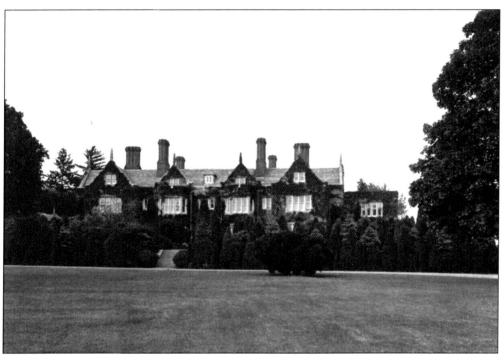

Hunter's daughter married Dr. J. Leslie Davis, "one of the most prominent and successful ear, nose, and throat experts in the eastern United States." The couple resided in the mansion from the 1920s until 1936. Davis served multiple hospitals, including Jefferson Hospital, the Philadelphia Municipal Hospital, and the Philadelphia Charity Lying-In Hospital. In addition, Davis was on the Free Library of Philadelphia's board of trustees from 1911 to 1936.

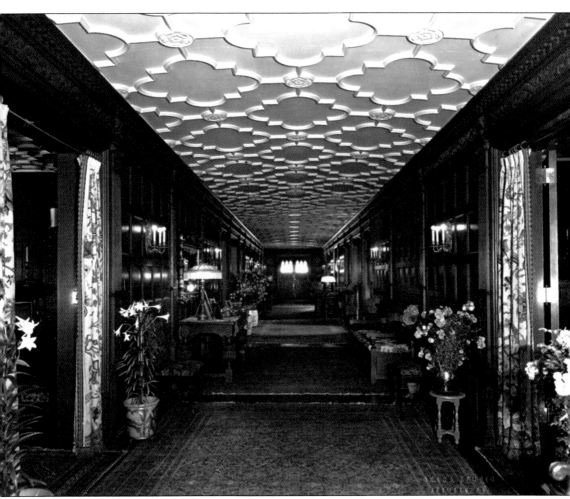

The interior of Coolkenny was laid out in typical Trumbauer fashion with the main rooms arranged around a central main hall. Coolkenny's first floor was wood paneled with ceilings of molded plaster. The spaces were decorated with fine antique furniture.

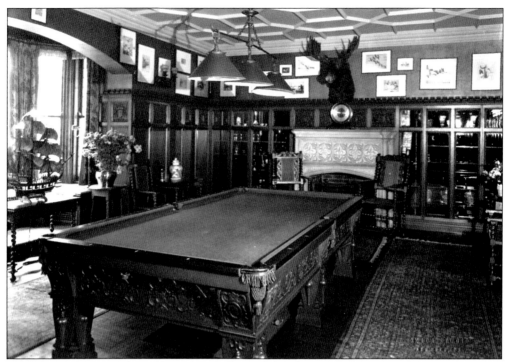

The principal rooms of Coolkenny, including a billiard room (above) and an enclosed porch (below), were located on the first floor. The billiard room was located on the mansion's north side, and the enclosed porch was located at the rear, beyond the service wing. The second floor contained several bedrooms, a dressing room, and a sitting room all arranged around the main hall. The service wing contained servants' bedrooms and bathrooms.

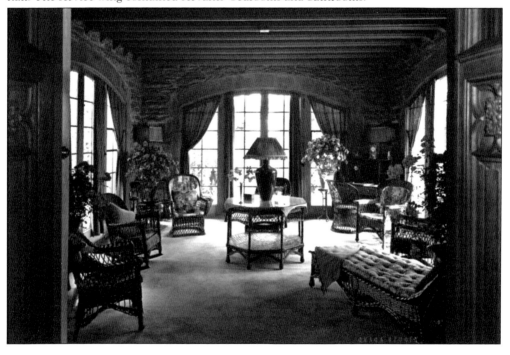

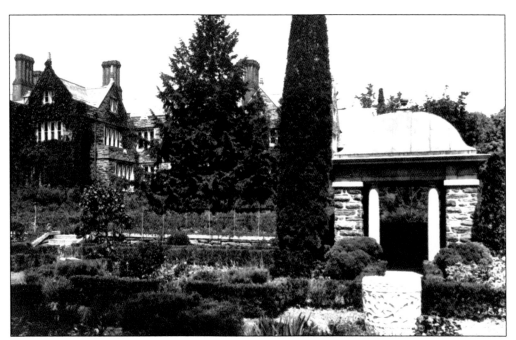

Terraces graced the east and south sides of Coolkenny, and a rose garden and conservatory were located on the north side. The family occupied the house until 1936, and then it sat vacant for the remainder of the 1930s. William Park owned the estate for the majority of the 1940s. After serving as a Pennsylvania Department of Highways office, Coolkenny was demolished to make way for an apartment complex.

In addition to designing the mansion, Trumbauer altered an existing stable and added several outbuildings. He turned the stable into a garage with chauffeur's quarters, and he added greenhouses and a gardener's cottage. The garage is the only building that escaped demolition in the early 1960s. Today it is a private residence.

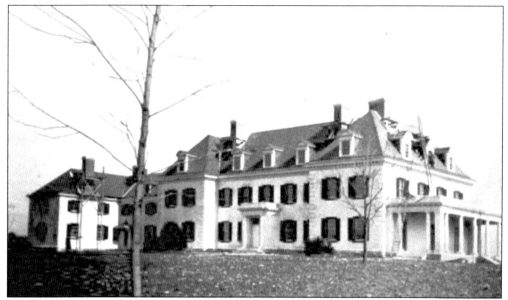

Located at 464 South Roberts Road in Bryn Mawr, Portledge was built between 1910 and 1911 for Theodore W. Cramp, head of the banking firm of Cramp, Mitchell and Shober. Cramp, who was related to the shipbuilder, commissioned the house for his daughter, Frances Alice, and her husband, Henry Pepper Vaux. The 28-room mansion is one of Trumbauer's many Georgian Revival–style mansions. The house, which was later owned by Cushing Junior College and Harcum Junior College, is now a private residence.

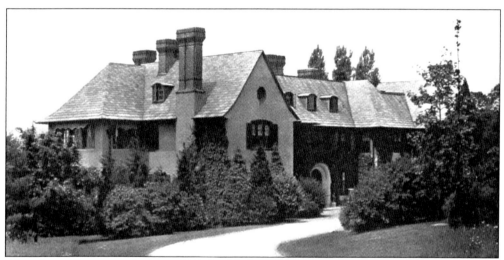

Almonbury House was built in 1911 for Herbert S. Darlington at 672 Conestoga Road in Villanova. The stucco facade is colored dark yellow and trimmed with brown. The arts and crafts–style house features an arched Italian doorway and French dormers. The slate roof is topped by large brick chimneys. The home still stands and is presently occupied by the American Missionary Fellowship.

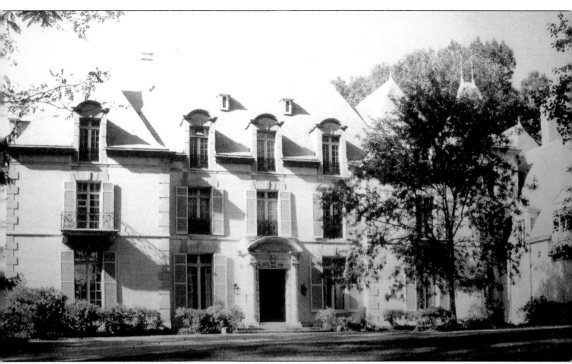

In 1911, cotton merchant George H. McFadden purchased Pregny, an estate in Villanova. The existing house was the summer home of naturalist Albert E. Gallatin. In 1912, the house was remodeled and enlarged by the architectural firm of Zantzinger and Borie. Later Trumbauer transformed the house into a 17th-century French-style chateau that McFadden named Bloomfield. The facades are of Indiana limestone and French Caen stone. Decorative dormers and chimneys grace the slate roof. Formal gardens surrounded the mansion, which still stands.

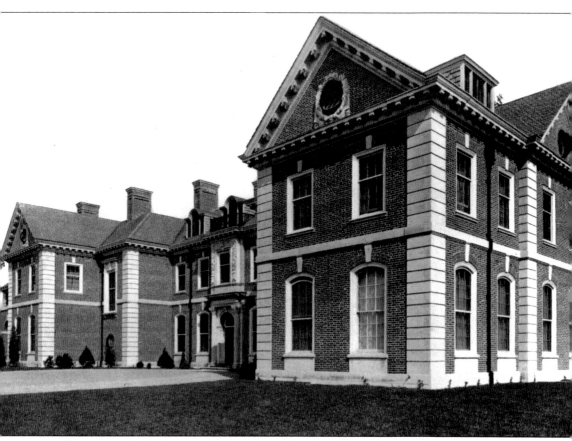

Ardrossan was built between 1912 and 1914 for Col. Robert Leaming Montgomery, a senior partner in the Montgomery and Company investment banking firm (later known as Janney Montgomery Scott). Trumbauer's inspiration for the Georgian Revival–style house came from Ernest Newton's Ardenrun Place in Surrey, England. The front facade features an English Renaissance–style entrance pavilion, a stone stringcourse, quoins, and Palladian dormers. Ardrossan's renown is largely due to Montgomery's daughter, Helen Hope Montgomery, who was a shy child who bloomed as a teenager. She married Edgar Scott, heir to the Pennsylvania Railroad fortune, in 1923. Hope Montgomery Scott lived a glamorous life, and her reputation as a free-spirited socialite endures to this day. Tracy Lord, the main character of Phillip Barry's *The Philadelphia Story* (1939), was based on Hope Montgomery Scott. The Broadway hit was adapted for the screen in 1940, and a later remake, *High Society* (1956), starred Grace Kelly. The estate, enlivened by its owners, came to embody the epitome of Philadelphia's Main Line society, a culture that sought to capture the life of the English gentry.

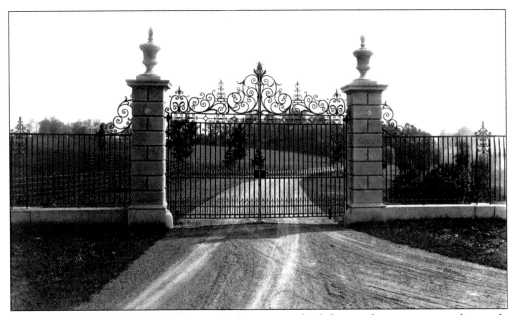

The mansion, which is just visible in the distance to the left, was the centerpiece of a nearly 800-acre estate that included stables, garages, staff cottages, and other historic residences. The estate is entered through an elegant gate on Newtown Road. Until the death of Hope Montgomery Scott in 1995, the gentleman's farm was also a working farm, featuring prized Ayrshire cows.

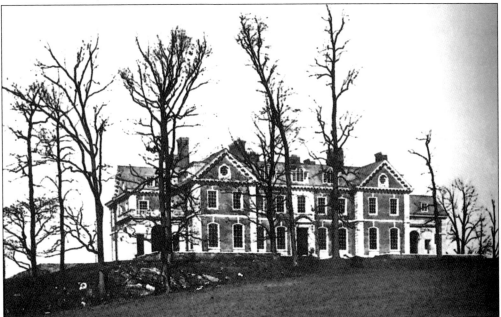

The rear facade includes a stone pavilion at each end of the mansion. Ardrossan still stands in Villanova. Hope's son Robert Montgomery Scott was the last family member to reside in the house. He died in 2005 and is remembered as a great philanthropist who brought his talents to bear as president of the Philadelphia Museum of Art and the Academy of Music. He enjoyed opening Ardrossan to local charities. While a majority of the original estate lands have been sold, the remaining 360 acres, including the main house, are currently for sale.

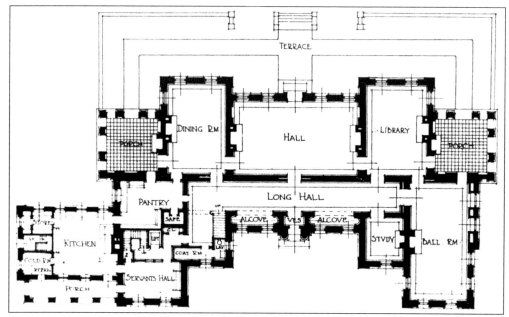

The rooms of Ardrossan are arranged in Trumbauer's typical manner, along a long transverse hall. Also in keeping with Trumbauer's design preferences, the house was set on a terrace, accentuating its elevation above the surrounding ground.

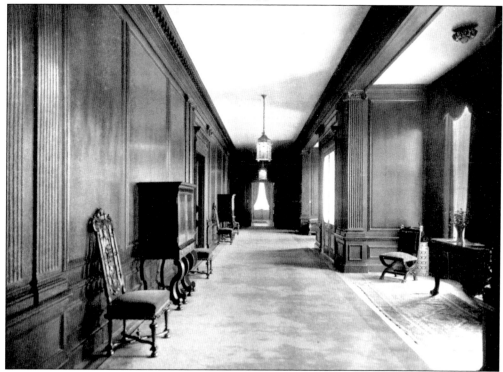

Ardrossan's entrance hall was paneled in oak. A set of doors directly across from the entrance leads to the living room, while an alcove containing a Carolean-inspired staircase is at one end of the hall. The pantry is located at the west end of the hall, and the ballroom is located at the east end.

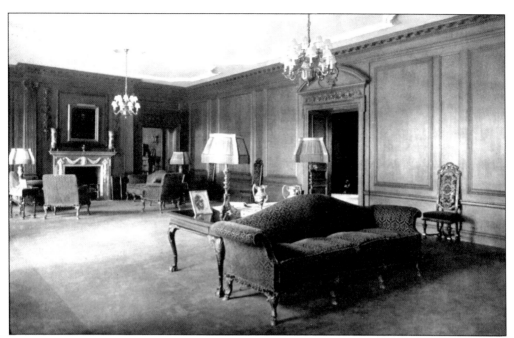

Ardrossan's interiors were decorated by the renowned London firm of White, Allom and Company. The living room's ceiling is divided into three sections, and chandeliers hang from the gaps between the sections. Corinthian pilasters flank the sides of each fireplace. The mantelpieces are of green and white marble. The room is filled with fine English antique furniture.

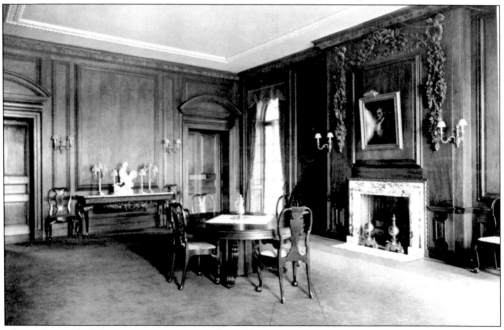

The oak-paneled dining room contained a table that could expand to seat 30 guests. Carved swags by Grinling Gibbons are above the mantelpiece. In addition to the antique furniture, the house was filled with fine portrait paintings of various family members by well-known artists dating back to Gilbert Stuart (1755–1828) and Thomas Sully (1783–1872).

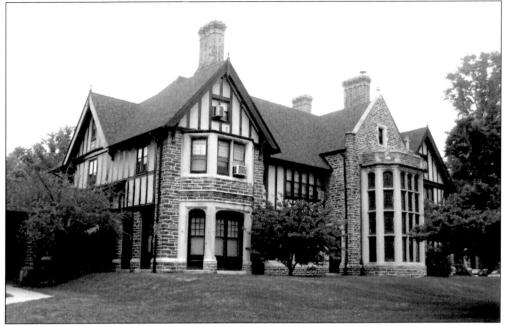

Dunroven was built between 1915 and 1917 in Lower Merion for insurance broker Edward M. Story of Samuel Story and Son. The Elizabethan-style mansion featured a beautiful bay window, generous half-timbering, and redbrick chimneys. Dunroven is now St. Mary's Hall of St. Joseph's University.

Clairemont was built between 1917 and 1919 for Morris Lewis Clothier, son of the Strawbridge and Clothier department store cofounder Isaac H. Clothier. Clairemont replaced a Victorian house by Addison Hutton (1834–1916). The white stucco walls of the English Regency–style mansion are accented by windows with dark shutters. Enchanting gardens by the Olmsted Brothers of Massachusetts surrounded the mansion. The mansion still stands, but the 161-acre estate has been reduced to 23 acres.

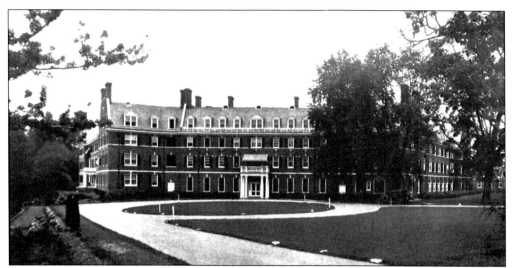

The Green Hill Farms Apartment Hotel, built in 1919 for Morris Wood, opened on March 7, 1921, at the northwest corner of City Line and Lancaster Avenues. The building cost $1,250,000 to construct and contained 150 suites plus a fine restaurant. In 1940, Eastern Baptist Theological Seminary relocated to the building. Now part of Eastern University, the seminary was renamed Palmer Theological Seminary in 2005.

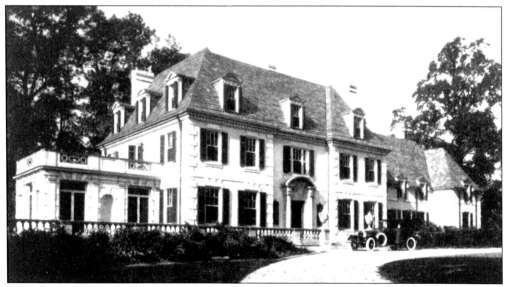

Corker Hill, designed by Furness, Evans and Company for Frank Thompson, was built in 1889. In 1920, John Heisley Weaver hired Trumbauer to remodel the residence. Trumbauer transformed Corker Hill into a French-style house renamed Maroebe. The house, which once stood on Merion Road between Highland Avenue and Latch's Lane in Merion, no longer exists.

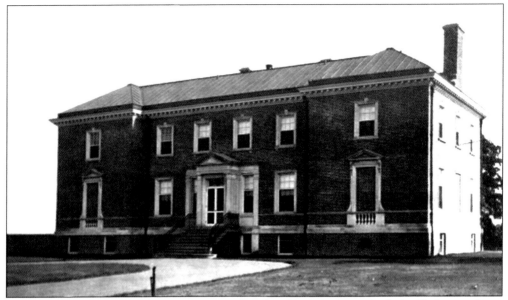

Craig Hall, still standing at 11 Coopertown Road in Haverford, was built for Katherine Craig Wright Muckle in 1925. Two years later, Muckle's husband wrote to Trumbauer and transcribed a message that artist Leon Dabo had written in their guest book, "The form, the letter, and above all the spirit of all that was fine, noble and distinguished in Colonial art and architecture is expressed in this beautiful home. The spirit of home, of hospitality allied to the rarely beautiful contents of this house constitute an honor, an event, and a distinguished memory."

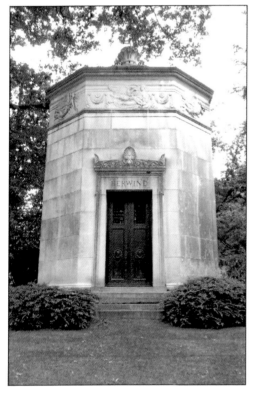

From modest homes for the middle class to extravagant palaces for the very wealthy, from civic buildings to commercial offices, Trumbauer designed it all, including mausoleums. The mausoleum for Edward J. Berwind stands in West Laurel Hill Cemetery. Berwind was a graduate of the United States Naval Academy and one of the founders of the Berwind-White Coal Mining Company. His summer cottage, the Elms in Newport, Rhode Island, was one of Trumbauer's first major commissions.

Three

CHESTNUT HILL AND THE WHITEMARSH VALLEY

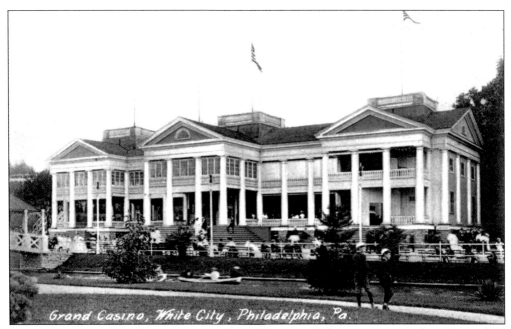

The grand casino was the centerpiece of the Chestnut Hill Amusement Park in Springfield Township. Also known as White City, the park opened in 1898 and was easily accessed by trolley. The park included amusements, a boating lake, and a bandstand. It closed after the 1911 season, and the land was sold to developers the following year. The site is now occupied by Philadelphia Montgomery Christian Academy.

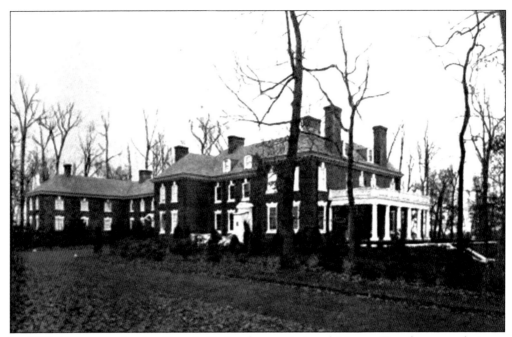

In 1905, investment banker Francis E. Bond commissioned Horace Trumbauer to design a residence. The American Federal–style Willow Brook House, which is located in Penllyn, was completed in 1907. This residence is unusual because Trumbauer rarely employed the American Federal style or the Greek Revival style. Most of Trumbauer's clients (Bond and Edgar C. Scott are exceptions) preferred the English and European styles popularized during the Gilded Age.

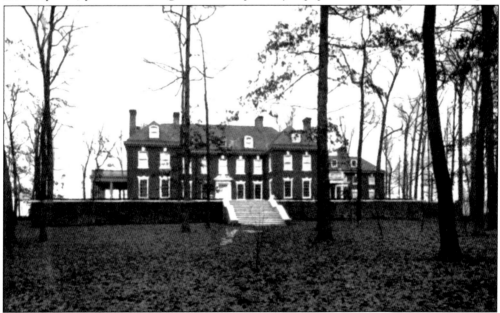

Willow Brook House features oversized windows that allow light to flood the interior. The brick and marble house is topped by a hipped slate roof and chimneys. It contains 30 rooms, including an oak-paneled great hall, a library, a children's dining room, and servants' quarters. Today Willow Brook House serves as Gwynedd-Mercy College's hallmark building.

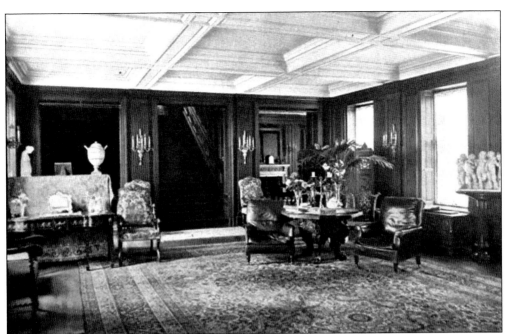

Visitors entered Willow Brook House through the main hall. The paneled walls were interrupted by huge windows separated by pilasters, enclosed stairs, a Caen-stone fireplace, and openings leading to the dining room, the library, and the coatroom. The Bond children enjoyed their own dining room and a spacious playroom on the third floor.

In addition to the house, Trumbauer designed a stable and laundry complex. Both were located near the service wing. The stable complex includes a carriage house, horse stalls, a wagon shed, a harness room, and two houses for the coachmen. Each house contained five rooms. The grooms occupied four rooms on the second floor of the carriage house. The complex is part of the Gwynedd-Mercy College campus.

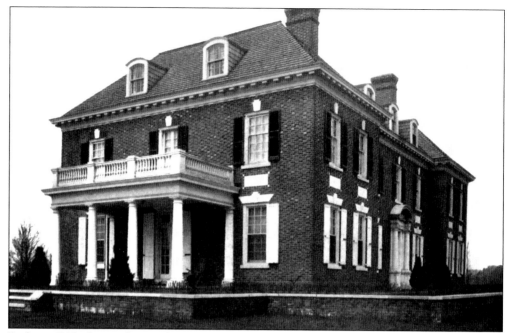

Built in 1905, the residence of Charles Porter Jr. and his wife, Florence Disston Porter, is still standing at 7811 Huron Street in Chestnut Hill. It is one of the best examples of the Georgian Revival style in Chestnut Hill. The house is two and a half stories, U shaped, and made of brick.

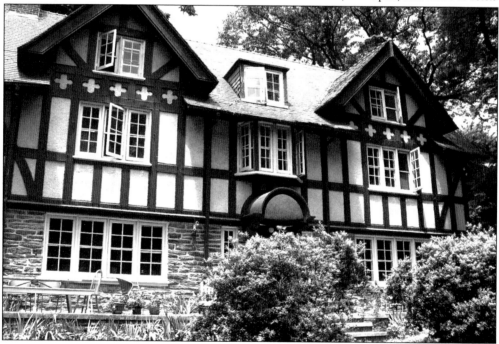

The residence of Helen Stinson Phelps, located on Mermaid Lane in Chestnut Hill, was built in 1911. The Tudor-style house features a first floor of stone and half-timbering above. The door is covered by an arched hood, and the second floor is graced by a centered bay window. Two gabled dormers and a single shed dormer protrude from the third floor. The house is still standing.

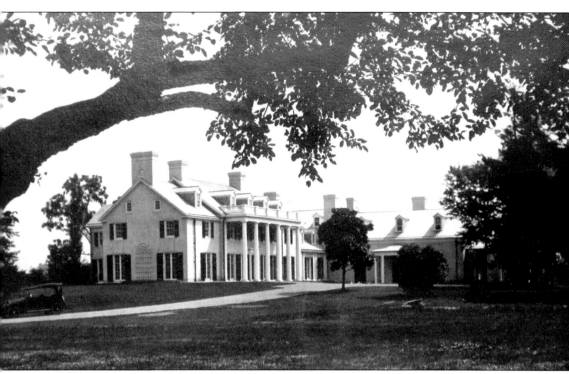

In 1912, George D. Widener Jr. purchased Erdenheim Farm, a celebrated stock farm that had been the birthplace of many noted horses dating back to the 1860s. There he raised his own thoroughbred racehorses. A renowned sportsman, Widener was chairman of the Jockey Club, president of Belmont Park, and honorary chairman of the New York Racing Association. He also owned a horse farm in Lexington, Kentucky. Between 1913 and 1926, Trumbauer left his mark on Erdenheim Farm by enlarging and modernizing the mansion and adding numerous outbuildings to the extensive grounds. Fitz Eugene Dixon Jr., Widener's nephew, inherited the estate in 1971. Dixon was a great patron of the arts in the Philadelphia region, best known for purchasing the *LOVE* statue that stands in the JFK Plaza in Center City. A sporting enthusiast, Dixon at one time or another was part owner of various professional Philadelphia sports teams. He owned the Philadelphia 76ers basketball team from 1976 to 1981 and is credited for hiring Julius "Dr. J" Erving in 1976. Like his uncle, Dixon continued to raise thoroughbred horses at Erdenheim Farm. Dixon resided at the estate until his death in 2006. Erdenheim Farm consists of five parcels of land that total about 450 acres. The central portion of the estate was bequeathed to the Natural Lands Trust by Widener. The Whitemarsh Conservancy is in the process of securing funds to either purchase or secure easements on the remaining land that is still owned by the Dixon family.

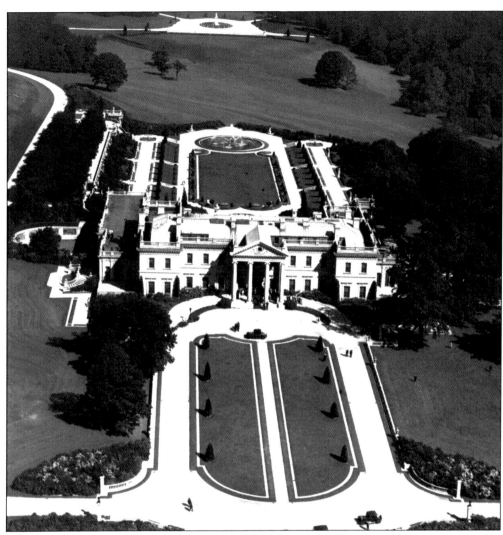

Whitemarsh Hall was built between 1916 and 1921 for Edward Townsend Stotesbury, a senior partner in the banking firm of Drexel and Company. Eventually the firm merged with J. P. Morgan and Company in New York. The immense English Palladian mansion, located in Wyndmoor, is considered Trumbauer's masterpiece. It sat amid a 325-acre estate. The main entrance was protected by a gatehouse on Willow Grove Avenue, although there were other entrances on Cheltenham Avenue and Paper Mill Road.

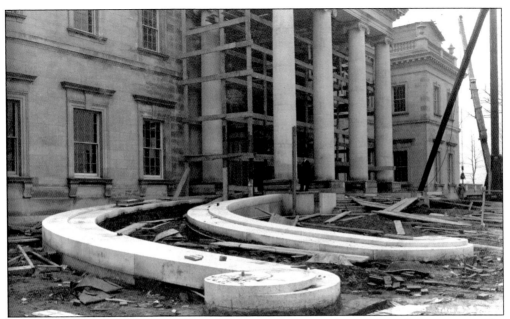

Trumbauer stands in front of the enormous Ionic columns that supported the portico. The pediment featured a round window accented by foliage. The building's facade was of smooth Indiana limestone and Italian marble and was dotted with windows and topped by urns. The mansion was built by the George A. Fuller Construction Company, a New York firm best known for building the Flatiron Building in that city. Whitemarsh Hall contained 147 rooms with more than 100,000 square feet of floor space. Stotesbury built the mansion for his wife, the former Eva Roberts Cromwell, whom he married on January 18, 1912.

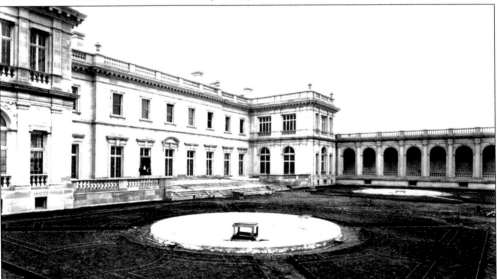

The eclectic garden elevation included French doors and a pavilion with Gallic details. Eva's 1917 letter to Trumbauer praised, "I have never been able to find an expression in words for the majestic simplicity and beauty of the new house which is so satisfying, so thrilling in its loveliness that it sometimes brings tears to my eyes when I see it at sunset or in the moonlight . . . this house must mean even more to you than it does to me, and you will value this tribute accordingly."

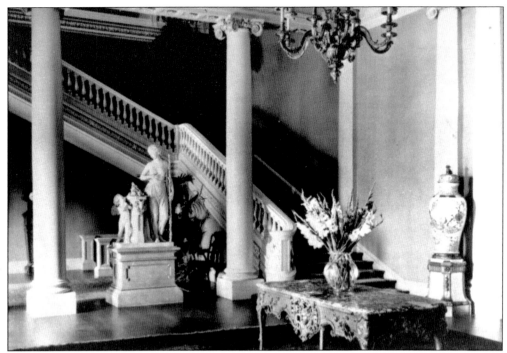

The entrance hall of Whitemarsh Hall was decorated by Charles Allom. The hall contained the painting *The Sacrifice of the Arrows of Love on the Altar of Friendship* by Jean Pierre Tassart (French, 1727–1788), which was once owned by Frederick the Great. A chandelier, a table from the Louis XIV period, Chinese porcelain jars from the Yung Cheng period, and a marble fireplace topped by a portrait of Edward T. Stotesbury by R. L. Partington (English, 1868–1929) decorated the room.

Eva Stotesbury supervised the construction of Whitemarsh Hall while living on the property. Occasionally, Eva's presence caused trouble. For example, she wanted a pipe organ in the ballroom, but Trumbauer refused. Then, Eva suggested the entrance hall, but Trumbauer refused again. Finally, ordered by Eva to find a place for it, Trumbauer fit it into the west gallery, just outside the ballroom.

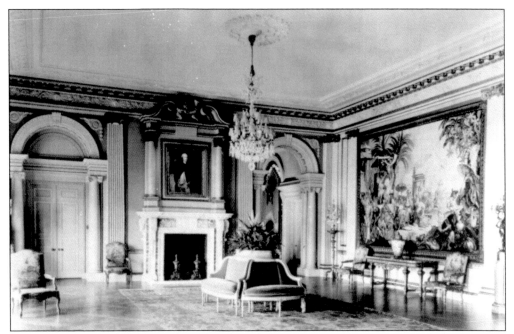

The walls of the salon were adorned with 17th-century French tapestries, and the floor was covered by a $90,000 Isfahan carpet. Chinese porcelain jars from the Yung Cheng period sat atop the tables while a portrait by George Romney (English, 1734–1802) hung above the fireplace.

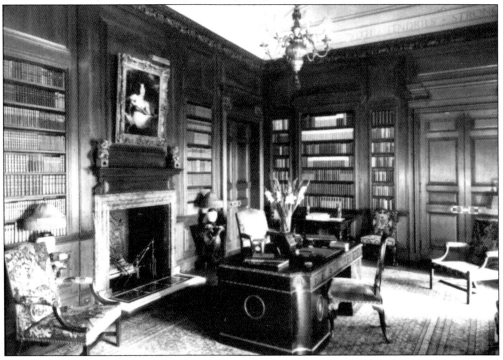

Stotesbury's study, also known as the small library, was located on the first floor between the ballroom and the drawing room. It was paneled and featured a barrel vault ceiling, a rare design for Trumbauer. Charles Allom decorated the room. While Stotesbury owned many books, he rarely read.

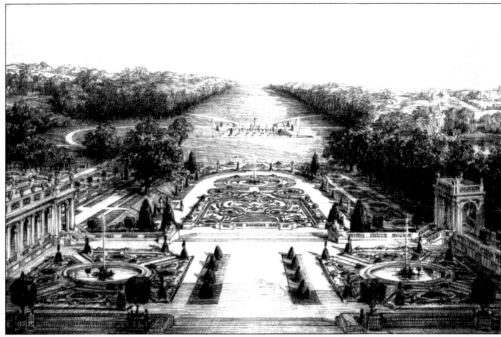

Jacques Gréber designed the formal gardens for Whitemarsh Hall. The drawing shows the gardens as he envisioned them. The photograph shows the gardens as they were finally executed. Because the grounds of the garden sloped, they were visible from the Willow Grove Avenue entrance. An upper terrace and a lower terrace extended from the house to the stairs that led down to the 250-foot-long *tapis vert* (green carpet of turf). A reflecting pool 90 feet in diameter was located at the end; its intricate fountains sprayed water straight up from the center and inward from the circumference. Some 70 gardeners maintained the property using 20 lawn mowers and eight tractors.

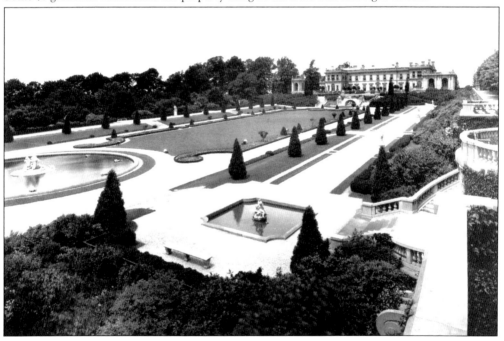

After Edward T. Stotesbury died, his wife closed Whitemarsh Hall and sold the mansion's contents. During World War II, New York's Metropolitan Museum of Art moved a portion of its collection to Whitemarsh Hall for safekeeping. In 1943, Whitemarsh Hall and 38 surrounding acres were sold to the Pennsylvania Salt Manufacturing Company for $167,000, and in 1946, the remainder of the land was sold to developer Matthew McCloskey. McCloskey's development, named Whitemarsh Village, contained 1,000 houses ranging in price from $8,800 to $9,800. From 1964 to 1980, the main house changed owners and deteriorated. Repeated vandalization throughout the 1970s, sealed the gutted mansion's fate. The ruins of Whitemarsh Hall were demolished by the Geppert Brothers in 1980.

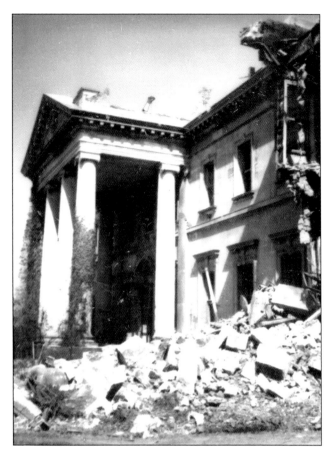

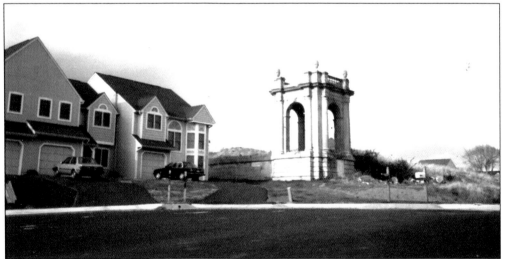

The land where the mansion once stood is now occupied by a housing development. The name of the development and the names of its winding streets are an attempt to perpetuate the names of the estate, its architect, and its owner. Six pillars, the foundations of the formal gardens, the entrance and the gatehouse, and scattered statues still dot the grounds, providing a reminder of a lost architectural masterpiece.

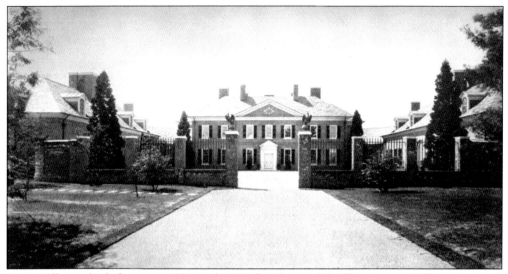

Briar Hill was built between 1929 and 1930 for George W. Elkins's son William McIntire Elkins. It was located across Thomas Road from Widener's Erdenheim Farms. Elkins was an investment banker and a philanthropist. The Georgian Revival–style mansion, set amid a 95-acre estate, incorporated elements of the American Federal style. The front facade featured two forward-projecting wings connected by curved arcades and a white marble front door surround. The styles of the interiors ranged from American Federal to Greek Revival.

In 1948, Briar Hill was sold to Rosabelle Deichelmann. Her husband, Dr. S. J. Deichelmann, turned the mansion into Eugenia Hospital, a mental institution. The hospital closed in 2004, and Briar Hill was later demolished to make way for the Hill at Whitemarsh retirement community.

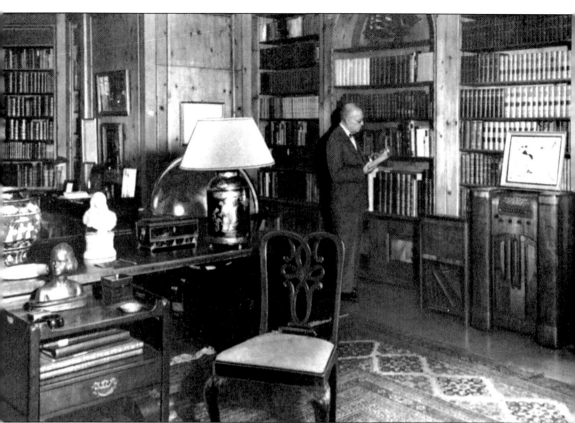

The library at Briar Hill was the most important room in the house. The furnishings and the art that filled the pine-paneled retreat came, in part, from Elstowe (Elkins's grandfather's house in Elkins Park). Elkins, like his cousin Harry Elkins Widener (two years his junior), was a great bibliophile and owned Charles Dickens's desk and desk accessories, which were displayed in the library. After Elkins's death in 1947, his widow gave the room and its contents to the Free Library of Philadelphia and put the estate up for sale. The room was reassembled at the library's central branch in the Rare Book Department and is open to the public.

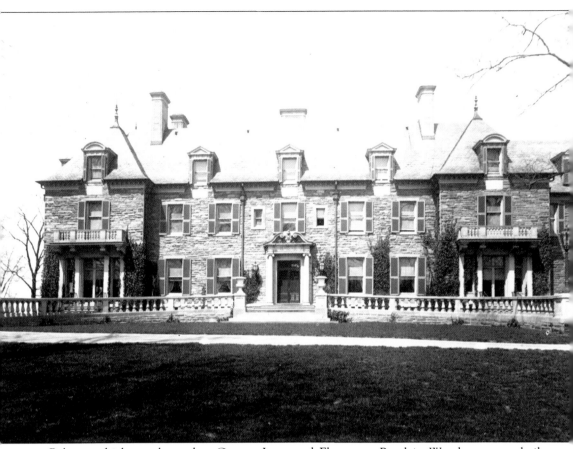

Rylston, which was located at Gravers Lane and Flourtown Road in Wyndmoor, was built between 1923 and 1924 for Charles H. Lea. The residence replaced a Victorian house by Collins and Autenrieth that previously occupied the site. Rylston was torn down in the 1960s.

Four

PHILADELPHIA

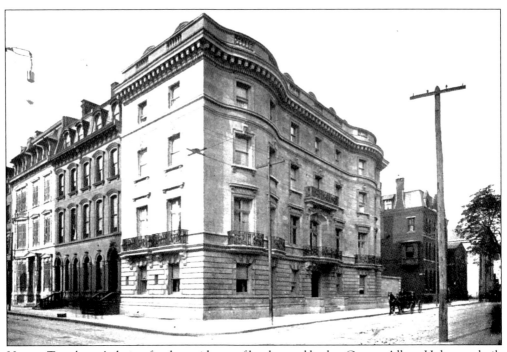

Horace Trumbauer's design for the residence of banker and broker George Albert Huhn was built between 1898 and 1900. The $200,000 home was located at the northwest corner of Sixteenth and Walnut Streets. The property was sold in 1915, and the home was promptly demolished. An office building replaced the residence.

The St. James Hotel was built between 1901 and 1904 at the southeast corner of Thirteenth and Walnut Streets. It was the first apartment building that Trumbauer designed. The 12-story brick building is supported by a fireproof steel frame. The distinctive Second Empire–style roof features dormers topped by pediments. The St. James Hotel has undergone numerous alterations that have compromised the original architectural design. The lower level is currently occupied by a bank and a dentist's office, while the upper floors contain residential apartments.

The Land Title Bank and Trust Company occupied two office towers. The shorter tower, designed by Chicago architect Daniel H. Burnham (1846–1912), was built in 1897. The taller tower, a collaboration between Burnham and Trumbauer, was built in 1902. In 1907, Trumbauer altered the banking room, and in 1928, he made alterations and additions to the basement, the first floor, and the third floor. Both buildings still stand on the west side of Broad Street between Chestnut and Sansom Streets.

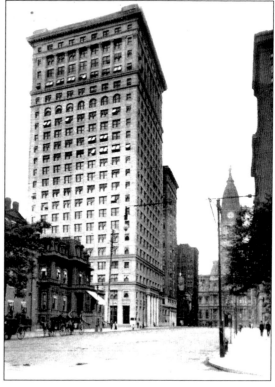

Garretson Hospital (originally known as the Hospital of Oral Surgery) was founded in 1879 by Dr. James E. Garretson. A modest hospital building designed by Trumbauer was dedicated on March 2, 1908, one year after the hospital had been acquired by Temple University. In 1921, Temple's founder, Dr. Russell E. Conwell, announced that the tiny hospital would be enlarged, renamed Greatheart Hospital, and moved from its site at Eighteenth and Hamilton Streets. The hospital was absorbed by Temple University Hospital. The Trumbauer-designed building was demolished.

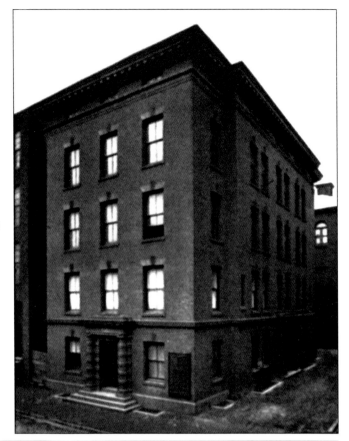

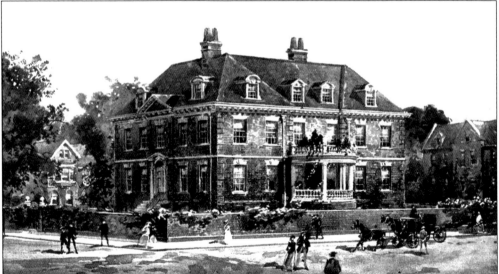

The residence of Joseph Benton McCall was built in 1902. Among his business interests, McCall was president of the Philadelphia Electric Company. His Georgian Revival–style residence was made of red brick and featured marble trimmings. It was located at the northwest corner of Forty-second and Walnut Streets but no longer stands.

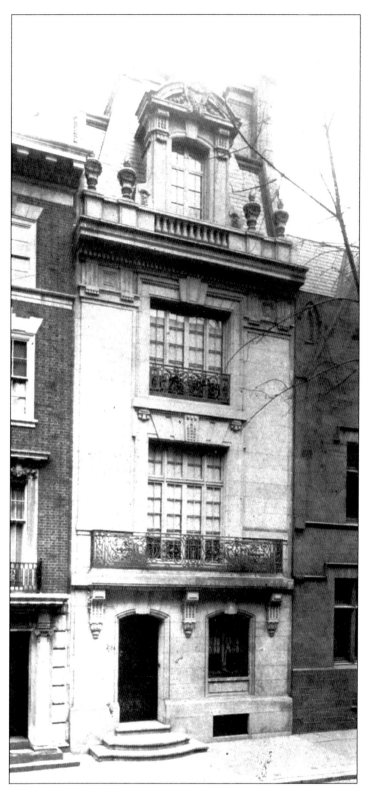

In 1902, Trumbauer designed a town house for sugar manufacturer and railroad tycoon Edward C. Knight Jr. and his family. This house is the smallest of Trumbauer's urban residential projects, but it is one of his finest. The front facade is only 20 feet wide. However, it masterfully incorporates bold design elements, including ironwork by Samuel Yellin, and captures the elegance of 18th-century French architecture. The building, built of Indiana limestone, stands at 1629 Locust Street and is currently owned by the investment banking firm of Dimeling, Schrieber and Park.

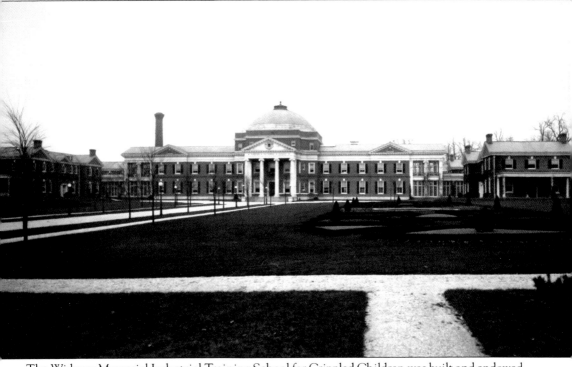

The Widener Memorial Industrial Training School for Crippled Children was built and endowed by P. A. B. Widener in memory of his wife, the former Hannah Josephine Dunton (1836–1896). The school, located on a 30-acre parcel at the southwest corner of Broad Street and Olney Avenue, opened in 1902. Limited to 100 students, the school admitted crippled children between the ages of 4 and 10 years who were later discharged when 18 to 20 years of age. Many suffered from infantile paralysis and tuberculosis of the spine. The school provided the students with the best medical and surgical care available in addition to industrial training. Trades taught at the school included farming, poultry raising, and market gardening. In 1912, Widener established a $4 million endowment for the school in memory of his son and grandson who perished on the *Titanic*. As treatments changed over time, enrollment at the school declined. The buildings were replaced in 1953, and the school is now for special education students. Girls High also occupies a corner of the site. Only the fine brick wall along Broad Street and the 1904 stable building survive.

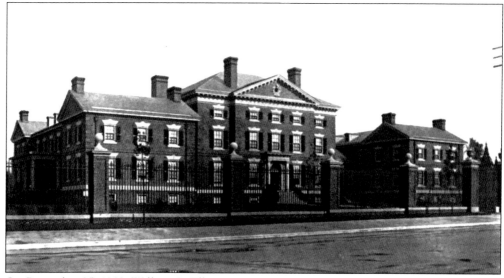

On December 25, 1902, William L. Elkins announced his intention to establish a home for the orphaned daughters of Masons. Elkins set aside land at the southeast corner of Broad Street and Torresdale Boulevard (now the Roosevelt Boulevard) and asked Trumbauer to design the building. The William L. Elkins Masonic Home for Orphan Girls opened in 1904 and contained offices, classrooms, libraries, and dormitories. The building is now the Prince Hall Grand Lodge of Pennsylvania.

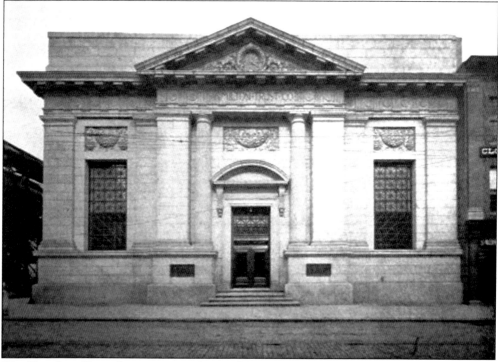

The Hamilton Trust Company was designed by Trumbauer in 1906. It stood at the corner of Fortieth and Market Streets. The bank closed on October 7, 1931, and the building was eventually demolished.

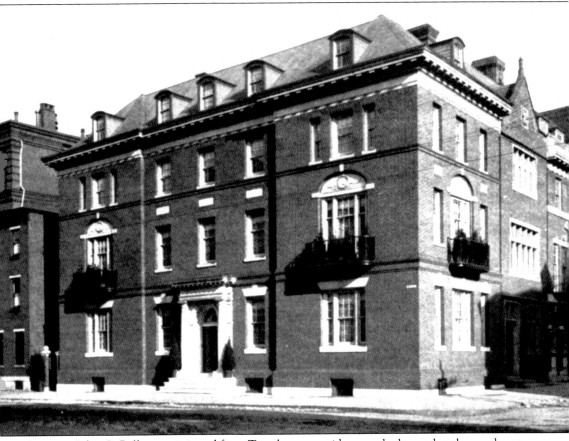

Attorney John C. Bell commissioned from Trumbauer a residence to be located at the northeast corner of Twenty-second and Locust Streets. Built by Doyle and Doak in 1906, the Georgian Revival–style house is made of brick and trimmed in limestone. Bell served as the district attorney of Philadelphia and as the attorney general of Pennsylvania. Bell argued two cases before the United States Supreme Court: *Commonwealth v. Patsome* and *Plymouth Coal Company v. Commonwealth*. The state won both cases. Bell's son, John C. Bell Jr., walked in his father's footsteps. He served as the lieutenant governor of Pennsylvania, the governor of Pennsylvania, and chief justice of the Pennsylvania Supreme Court. The mansion was converted into apartments in 1944.

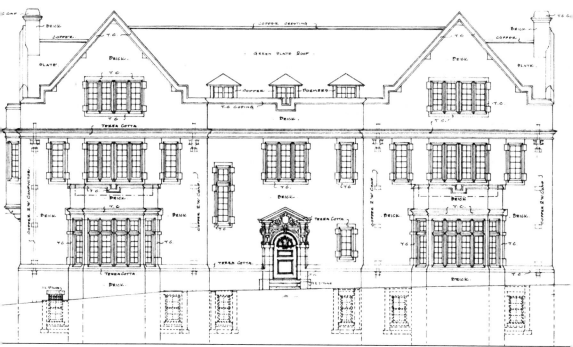

Trumbauer designed the building of the Athletic Association of the University of Pennsylvania at Thirty-third and Spruce Streets in West Philadelphia. Built in 1905, the structure was designed to complement its neighbor, Frank Miles Day's Weightman Hall. Currently, the building is known as the James D. Dunning Coaches' Center.

The Racquet Club of Philadelphia, founded in 1889 as a private athletic and social club, moved from its original clubhouse at 923 Walnut Street to a new Trumbauer-designed Georgian Revival–style clubhouse on Sixteenth Street in 1907. The $1 million building was described at the time as "the most sumptuous and perfectly equipped clubhouse in the world." The club remains active in the social life of Philadelphia.

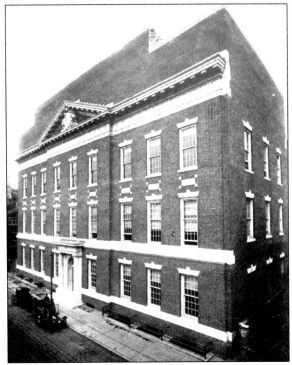

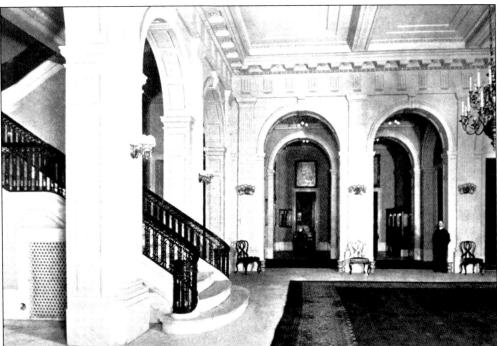

The interior of the Racquet Club of Philadelphia exemplifies the Georgian Revival style. The hall features Doric pilasters, paneled arches, and a coffered ceiling. Dining rooms are located on the first floor, the second floor contains apartments and offices, and the playing courts and the swimming pool are located on the third and fourth floors.

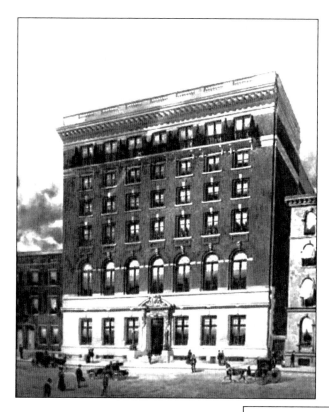

The YMCA building, located at 1421 Arch Street, was built in 1907. The Georgian Revival–style building is made of brick and concrete and features a balustrade atop the seventh floor. Five years later, Trumbauer designed the adjoining Elkins Memorial building. The Elkins building is similar to the original YMCA building but is more elaborate. Both buildings were renovated in 1985 before becoming the offices for the Philadelphia district attorney. In 2007, a portion of the buildings was sold to a hotel developer.

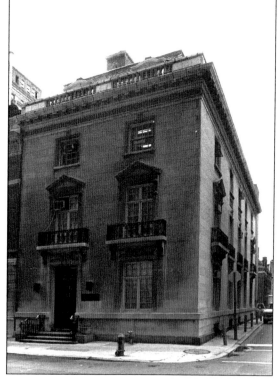

The city residence of banker Theodore W. Cramp was designed in 1908 and built at 1720 Locust Street. (Trumbauer would later design Portledge for Cramp in Bryn Mawr.) After the Curtis Institute of Music purchased the French classical–style residence in 1924, architect Horace W. Sellers (1857–1933) converted the house into a school building. Elizabeth Arden purchased the property in 1943 from the Curtis Institute and used it as a salon. In 1970, the Curtis Institute reacquired the building, and it is now known as the Milton L. Rock Resource Center.

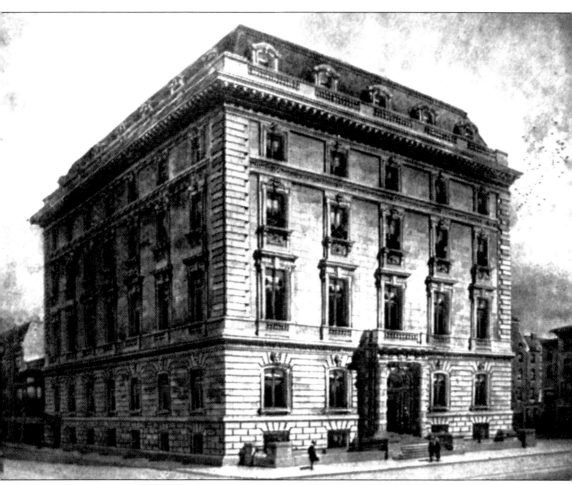

The Union League of Philadelphia was founded in 1862 to support the Union cause and the policies of Abraham Lincoln at a time when such sentiments were not popular in Philadelphia. In 1865, the Union League moved to a new clubhouse at the southwest corner of Broad and Sansom Streets. In 1909, the cornerstone was laid for the Trumbauer-designed Fifteenth Street Annex. The addition is made of granite and Indiana limestone.

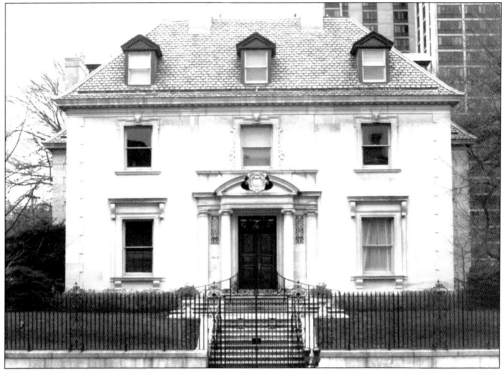

The residence of cigar manufacturer Otto Eisenlohr at 3812 Walnut Street was built between 1910 and 1912. It was constructed on the former site of the Anthony J. Drexel mansion. The French-style residence is made of limestone, and the front facade features symmetrical chimneys. Currently, the mansion is owned by the University of Pennsylvania and serves as the residence of its president.

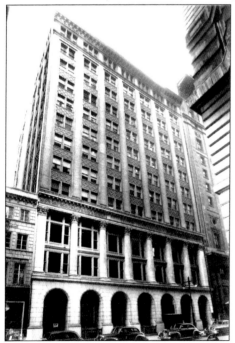

The Philadelphia Stock Exchange building was constructed in 1911 on Walnut Street, west of Broad Street. Previously the exchange was located at Independence Square. The new building was commissioned by a group of industrialists including William Deakyne, William M. Elkins, and Otto Eisenlohr. The Beaux-Arts building features a Corinthian colonnade atop a one-story arcade. The exterior above the dentiled cornice resembles the exterior of Louis Sullivan's Wainwright Building in St. Louis, Missouri. The stock exchange has since relocated, but the building still stands and is listed on the National Register of Historic Places.

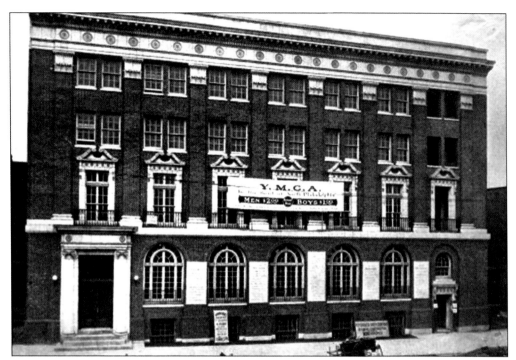

Trumbauer designed the YMCA North Branch at 1007 Lehigh Avenue. It was built during the second decade of the 20th century and still stands. The building has been divided into two sections, which contain the James F. Young Community Center and a Philadelphia police station.

The Adelphia Hotel was built in 1912 at the northeast corner of Thirteenth and Chestnut Streets. The Georgian Revival–style hotel is made of brick and trimmed in terra-cotta and wood. The base is topped by a light iron cornice, windows surrounded by stone, another cornice, and windows draped in stone. The former hotel building is now apartments.

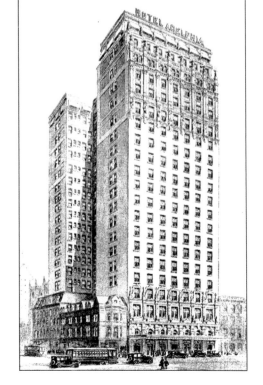

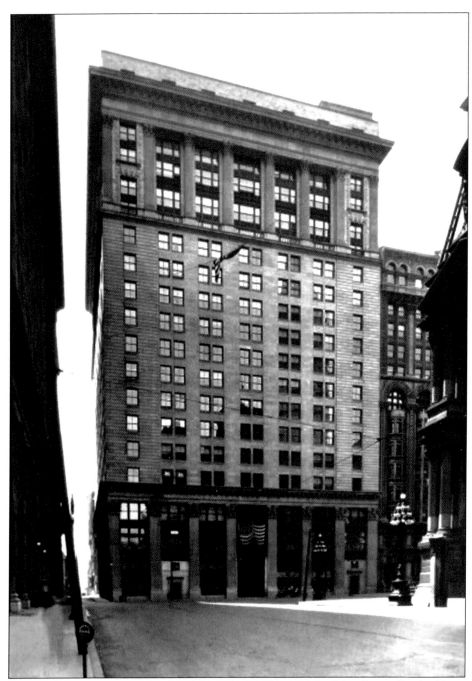

The Widener Building was built in 1915 for P. A. B. Widener. The $5 million office building was erected at One South Penn Square, where the former Mint Arcade was located. The Widener Building features an arcade extending from Penn Square to Chestnut Street. This building has a colorful history. It has endured multiple fires, witnessed several suicides, and faced condemnation of the fourth and fifth floors by the FBI in 1971, so that it could avoid signing a five-year lease. For many years, the highly regarded jeweler J. E. Caldwell and Company was located on the ground floor. The building still stands.

The Beneficial Saving Fund Society building opened for business in 1916 at the corner of Twelfth and Chestnut Streets. The bank building cost $400,000 to build and replaced a prior building that had burned. The classical revival–style bank resembles a Roman structure rather than a Greek structure, and the classical elements are balanced with modern Beaux-Arts elements.

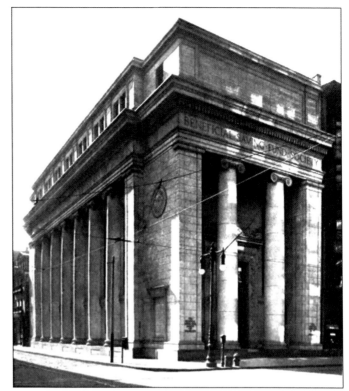

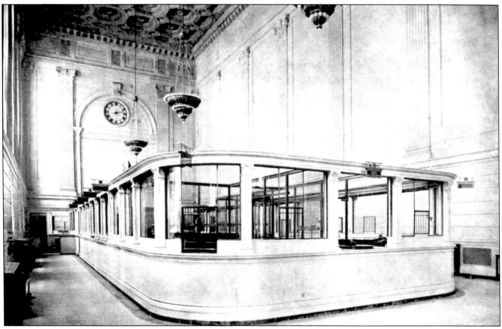

The banking room, which was located on the first floor, featured walls with spaced pilasters, a clock on the wall, and a high coffered ceiling. The space remains virtually unchanged. In 2006, Beneficial Savings Bank sold the building to the Girard Estate Trust, the trust set up by Stephen Girard to oversee and fund Girard College.

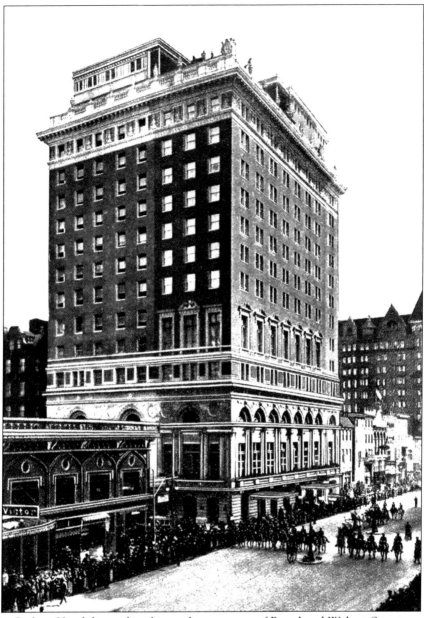

The Ritz-Carlton Hotel, located at the southeast corner of Broad and Walnut Streets, was built in 1911 for George D. Widener. Widener decided to build the hotel after his wife was scolded for lighting a cigarette in the Bellevue Stratford Hotel, located directly across Broad Street. Shortly after the hotel's completion, Trumbauer's work was praised in the newspaper: "Coming back to the planning and to the work of Mr. Trumbauer, anybody who goes through the Ritz-Carlton of Philadelphia must be struck by the extraordinary ingenuity displayed in using up every available inch of the limited space at his disposal, and it has been truly said that more has been got out of the small plot at the corner of Broad and Walnut Streets than any other plot in the city." The hotel was enlarged by two thirds in 1913 due to its success. The old and new portions are distinguishable above. In 1912, Widener traveled to Paris to find a chef for the hotel. He perished on the *Titanic* as he made his return voyage; the chef was not aboard.

Every room of the Ritz-Carlton was outfitted with the finest furniture and decorations, especially the public rooms. The Palm Court and the ballroom are notable examples. These rooms were accessed by every guest, and they became synonymous with the hotel's luxury.

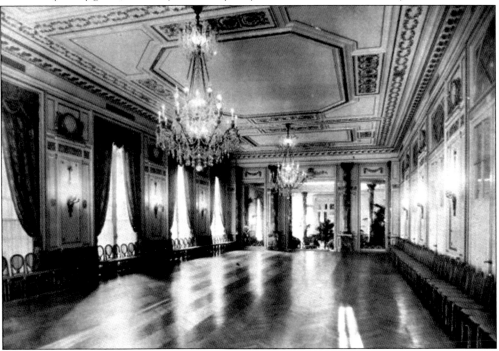

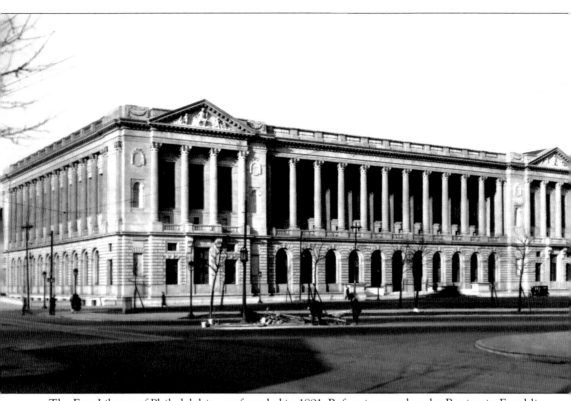

The Free Library of Philadelphia was founded in 1891. Before it moved to the Benjamin Franklin Parkway, its collections were spread between three insufficient spaces. In 1906, it was decided that the library should be along the proposed Benjamin Franklin Parkway, and in 1910, a site on Logan Square was chosen. In 1911, Philadelphia mayor John E. Reyburn selected Trumbauer to design the library's central branch. Despite numerous setbacks, ground was broken in 1917 and construction began in 1920. The Beaux-Arts building was completed in 1927. The building is supported by steel, and the facade is of limestone. The facade features enormous Corinthian columns and carved pediments. Currently the building is in the process of being restored, and the library is planning a significant expansion to the north side of the building.

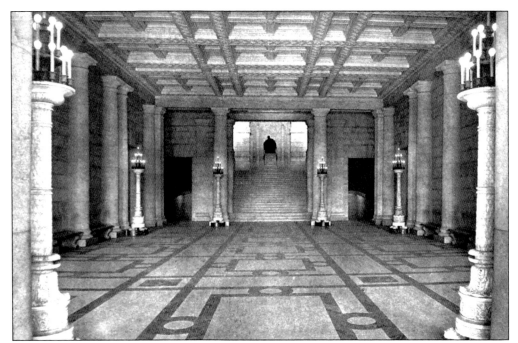

The interiors of the library were decorated and furnished by the F. W. Mark Construction Company and its subcontractors. The entrance hall features a bronze statue of Dr. William Pepper, founder of the Free Library of Philadelphia.

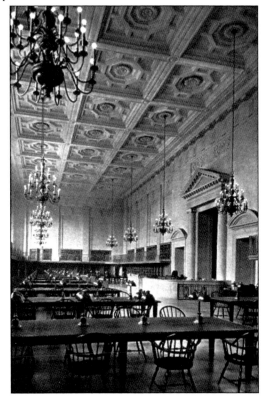

The Art Metal Company of New York was selected to provide the library's furnishings and equipment. The Art Metal Company provided fireproof tables, chairs, lamps, and cabinets. The lamps and the chandeliers that lit the main reading room have been replaced.

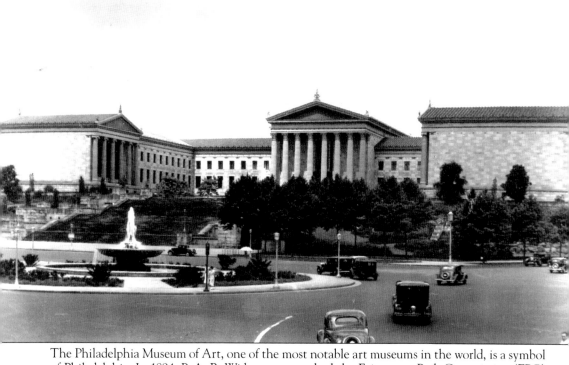

The Philadelphia Museum of Art, one of the most notable art museums in the world, is a symbol of Philadelphia. In 1894, P. A. B. Widener approached the Fairmount Park Commission (FPC) and offered to build a new art museum. At that time, the collections were exhibited in Memorial Hall. The FPC convinced the two city councils to approve an appropriation to fund a design competition. Henry Bacon of McKim, Mead and White won the competition. Bacon's museum was not built, and the project came to a halt. In 1902, the FPC and the city parks association formed the Parkway Association to revive the project. The city began to acquire land for the parkway and the new art museum in 1906. Despite numerous delays and setbacks, the completed Philadelphia Museum of Art was dedicated on March 6, 1928. Delays were caused by landscape issues, city politics, funding, and the conflicting visions of the two architectural firms selected to execute the project, Trumbauer and Zantzinger, Borie and Medary. For example, the firm of Zantzinger, Borie and Medary envisioned a museum consisting of several buildings situated around a court while Trumbauer opposed the idea. Howell Lewis Shay of the Trumbauer firm worked out a compromise. The museum would be E shaped, and it would consist of three connected temple facades facing a central courtyard.

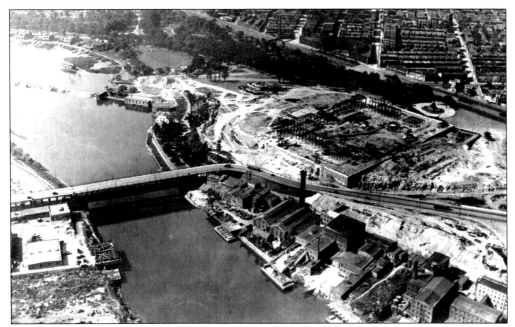

The construction firm of George A. Fuller was selected to build the museum. Construction of the foundation began on July 28, 1919, and the contract for the steel skeleton was awarded to the American Bridge Company on January 5, 1922. The construction proceeded slowly as the builders worked from the two ends toward the center of the structure. Construction proceeded in this manner thanks to lawyer Eli Kirk Price, because he convinced the FPC that should a political conflict arise, the city would be obligated to add the missing center portion. The exterior was competed in 1927. When the galleries opened in 1928, the interior was incomplete.

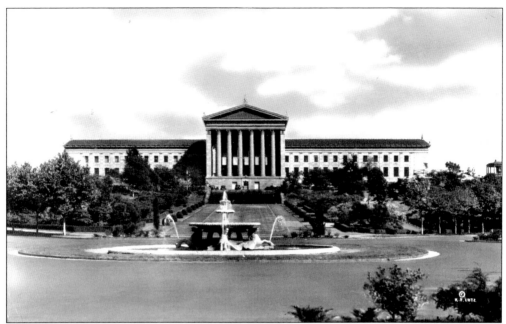

The Philadelphia Museum of Art is made of Minnesota dolomite with terra-cotta details. The Greek temple–styled museum features elements of the Corinthian, Doric, and Ionic orders. The capitals are colored, antefixes top the roof, and majestic creatures monitor the court.

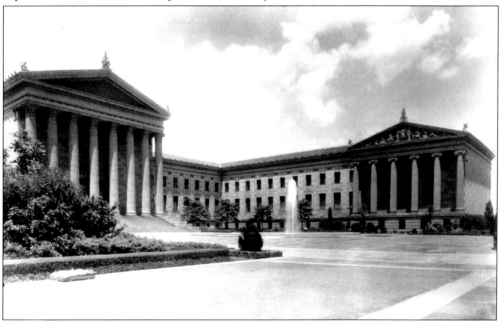

The architects intended to fill each of the eight pediments with sculptures. The brick was supposed to be temporary. However, only the northeast pediment on the interior courtyard side was completed. C. Paul Jennewein's *Western Civilization* features colored sculptures of allegorical figures. Zeus, the pediment's central figure, stands 12 feet tall and weighs about a ton. The Atlantic Terra Cotta Company in Perth Amboy, New Jersey, manufactured the figures as well as the roof tiles and all the terra-cotta edging that trims the building.

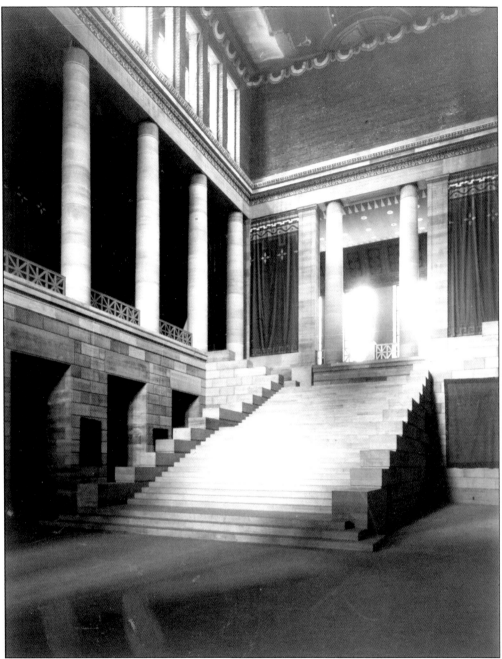

Architectural historian Fiske Kimball became director of the museum in 1925. He determined the layout of the museum's collections. In 1928, the library, the education department, and offices were located on the ground floor. The galleries were located on the first and second floors. Originally the great stair hall was open to natural light at both the east and west ends with clearstory windows to the north and south. Later the west windows were closed off and the statue *Diana* (1892) by Augustus Saint-Gaudens (1848–1909), was placed at the head of the staircase. The statue originally stood atop the first Madison Square Garden in New York City. It was removed in 1925 and came into the museum's collection in 1932.

The Equitable Trust Building, which is listed on the National Register of Historic Places, was erected in 1922 at 230 South Broad Street for Louis Cahan. The building features an arcade with Gothic windows, a brick shaft, and a unique stone cap. The lower floors were occupied by the Locust Street Theatre until 1982. An upscale restaurant and a bank occupy the lower floors, and the upper floors are offices.

Trumbauer designed the Beneficial Saving Fund Society's Kensington Branch around 1923. The bank still stands at 828 East Allegheny Avenue but has been significantly altered; an addition was put on, an ATM blocks the original entrance, and the engraved lettering has been covered.

The Social Service Building, built in 1923 at 311 South Juniper Street, was designed to house over 30 private welfare agencies. The simple Federal Revival–style building is of red brick, limestone, and terra-cotta. The building is L shaped and includes a service wing. The yard was converted into a parking lot around 1960. The building is currently owned by the University of the Arts.

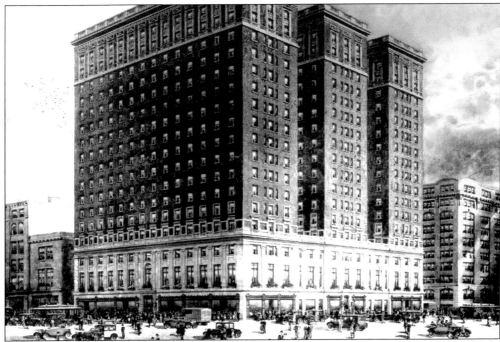

The Benjamin Franklin Hotel opened in 1925, shortly before the 1926 Sesquicentennial Exhibition, at the southeast corner of Ninth and Chestnut Streets. The 18-story Georgian Revival–style hotel replaced the famed Continental Hotel. The base of the hotel is made of granite and limestone, and the upper floors are made of brick and terra-cotta. The Benjamin Franklin Hotel closed in 1980. In 1986, it was restored and converted into an apartment/office building.

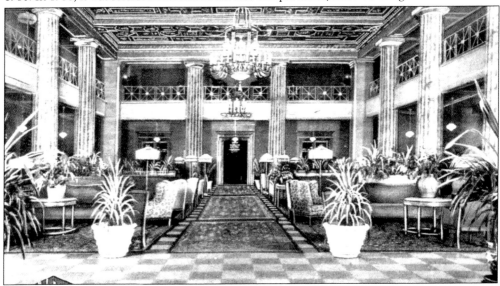

The Benjamin Franklin Hotel lobby is accessed from both the Ninth Street and Chestnut Street entrances. The lobby ascends two stories and is surrounded by a gallery on the second floor. The floors, walls, stairways, and Doric columns are marble. The decorated plaster ceiling features floral motifs and figural panels inspired by the designs of Josiah Wedgewood. Two chandeliers confirm the opulence of the lobby. The lobby and the ballroom still host weddings, proms, and parties.

The Bankers Realty Building was built for Albert Greenfield and Company in 1923. The Beaux-Arts building is located at 1313–1317 Walnut Street in Center City. The front facade faces narrow Juniper Street. In 1925, Trumbauer designed an addition for the building. The 17 stories are currently occupied by offices.

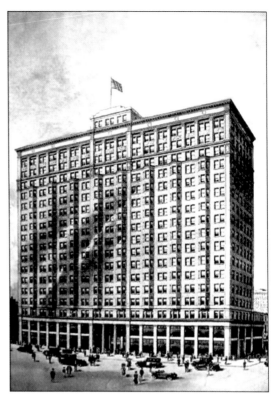

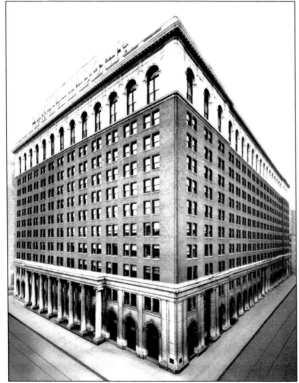

The Public Ledger Building was built between 1923 and 1927 (in three phases) in Old City by contractors Doyle and Company. The Georgian Revival–style building was commissioned by publisher Cyrus H. K. Curtis. Curtis enjoyed a private suite on the 10th floor and entertained in a private club on the 9th floor. The Public Ledger Building contained several technological innovations. It is supported by a steel skeleton, and it utilizes a water duct system beneath the raised floors. Today the building is home to many offices, including several consulates, and the Down Town Club.

Irvine Auditorium was built between 1926 and 1932 for the University of Pennsylvania. It seats 1,260 people and houses the Curtis Pipe Organ, which was built for the 1926 Sesquicentennial Exhibition and is one of the largest organs in the world. The building is now part of the Perelman Quadrangle. It was restored in 1995–2000 by Venturi, Scott Brown and Associates.

· WEST ELEVATION ·

The Northern Home for Friendless Children was founded by Elizabeth Hutter in 1853 and was originally located at Twenty-third and Brown Streets in Philadelphia. In 1927, Trumbauer designed and altered several buildings for the Northern Home at 5301 Ridge Avenue in Roxborough, and in 1928, the institution moved into its new quarters. It is now called the Northern Home for Children, and it continues to provide services and support to needy children.

While Trumbauer's firm produced many architectural masterpieces, there were designs that were never executed. Some, like a proposed residence for John Wanamaker, likely did not satisfy. Other designs were made for submission in competitions and the like and were not selected. In 1927, Trumbauer designed several versions of a station for the Baltimore and Ohio Railroad. The building would have been located on the block bounded by Market, Chestnut, and Twenty-fourth Streets and Schuylkill Avenue in Center City.

Most architectural drawings are altered before construction begins. The 1927 design for Hahnemann Medical College was no exception. This early drawing was modified. The hospital was shortened, and the details were refined. Originally the directors had wanted the hospital to overlook the parkway, but the FPC would not allow it.

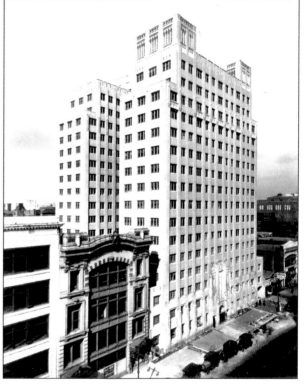

The Hahnemann Medical College building is located on North Broad Street between Race and Vine Streets. The art deco building is E shaped with three wings. It stands 17 stories tall and is made of brick, limestone, and reinforced concrete. Every room is soundproof, and there are three sunrooms on each floor.

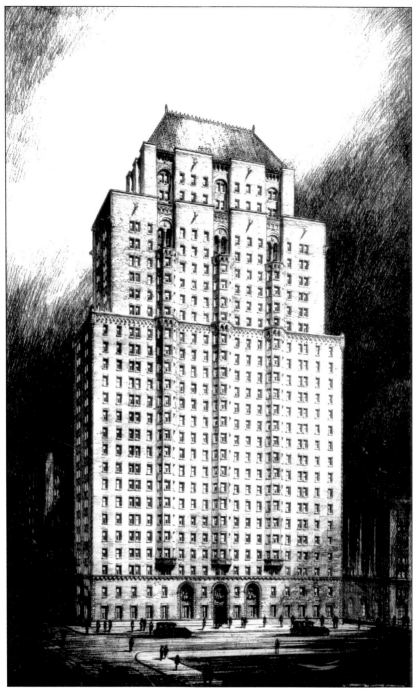

The Chateau Crillon was built in 1928 at the corner of Nineteenth and Locust Streets, on the west side of Rittenhouse Square. The building, originally a hotel, illustrates Trumbauer's ability to embrace changing tastes. In the late 1920s, the classical styles of the American Renaissance were rejected and the art deco style gained prominence. The art deco building is made of yellow brick and features Lombardic Romanesque limestone details. A high-peaked chateau-style roof tops the 27th story. The former hotel is now a Korman Communities apartment building.

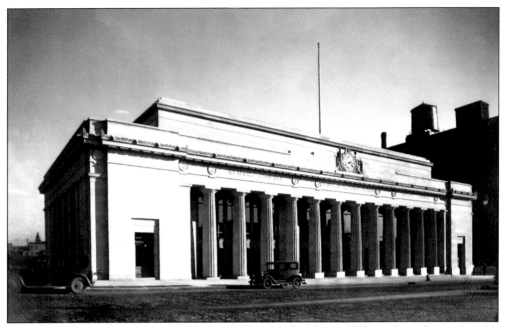

The North Broad Street station of the Reading Railroad was dedicated on September 30, 1929. Three of the richest men in the country—Andrew W. Mellon, Edward T. Stotesbury, and Joseph E. Widener—were present. The $2 million station was built across the street from Baker Bowl, the home park of the Phillies baseball team. Despite high expectations, the Greek Revival–style station failed. It was converted into the Inn Towner Motor Hotel in 1969. The owner of the hotel altered the interior. The hotel failed. The building, which has been divided internally into three smaller units, still stands.

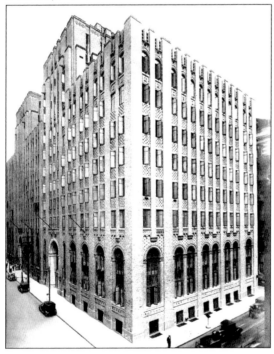

The Jefferson Medical College building was built in 1929 at 1025 Walnut Street. In 1931, Trumbauer added an enormous wing at the northwest corner of Tenth and Wal Streets. The wing was named the Curtis Building in honor of benefactor Cyrus H. K. Curtis. The complex cost $3 million to construct. The Jefferson Medical College building is supported by a steel frame and is fireproof. The roof was constructed in a manner that allowed for the construction of four additional floors. The Curtis Building was designed to match the Jefferson Medical College building. Both structures still stand.

Five

PHILADELPHIANS FARTHER AFIELD

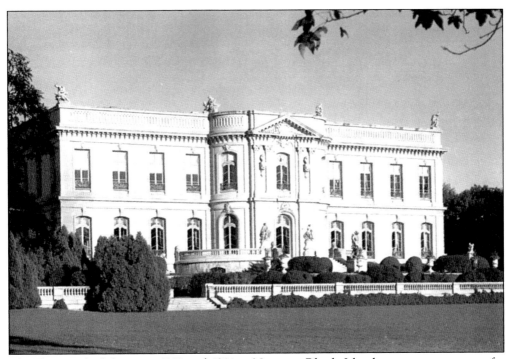

The Elms was built between 1899 and 1901 in Newport, Rhode Island, as a summer cottage for Edward J. Berwind. Berwind, the son of Prussian immigrants (his father was a cabinetmaker), cofounded the Berwind-White Coal Mining Company. Due to his connections and the company's major contracts, the coal company became the most successful coal distributor in the country.

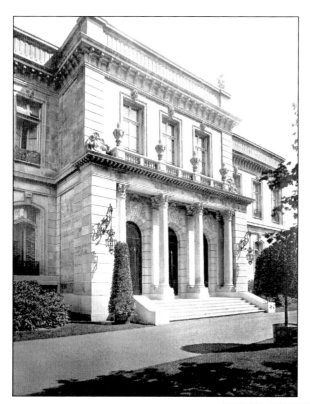

The Elms was Horace Trumbauer's first French-style home. The limestone exterior incorporated architectural elements that came from the Chateau d' Asnières (designed by Jacques Hardouin-Mansart de Sagonne [1709–1776]) and sculpture by artist Guillaume Cousteau the Younger (French, 1716–1777). Trumbauer improved de Sagonne's design by adding a terrace, narrowing and heightening the mansion, and eliminating the escutcheon. In addition, Trumbauer employed the latest technology, including steel and fireproof materials.

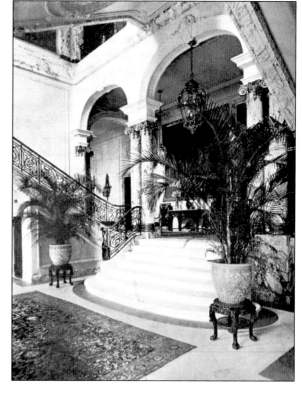

The interiors of the Elms were decorated by Julles Allard and Lucien Alavoine. Visitors arrived in the center hall after passing through the foyer and ascending a marble stair. The foyer and the hall are of Caen stone with purple Breche Violette marble columns and pilasters. The hall is decorated with murals from the Palazzo Cornaro in Venice, depicting the life of the Queen of Cypress, Caterina Cornaro. The double flying staircase is considered by many to be the finest of its kind in America.

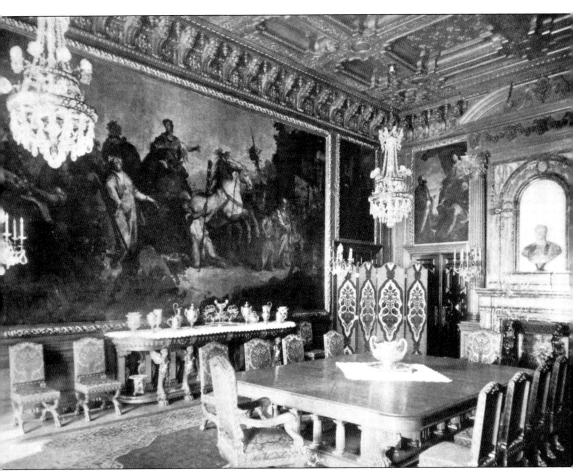

The Italian Renaissance–style dining room is paneled in oak, and the doors are of Honduran mahogany. The magnificent ceiling is plaster that has been grained to match the walls. The room contains two murals from the Palazzo Cornarom that depict the victories of Alexander and Scipio Africanus, a bust of Caracalla, and a statue of Diana the huntress. In 1961, the Berwind family sold the Elms to developers who intended to demolish the masterpiece to make way for a mall. The Preservation Society of Newport County saved the house, and it is now open to the public.

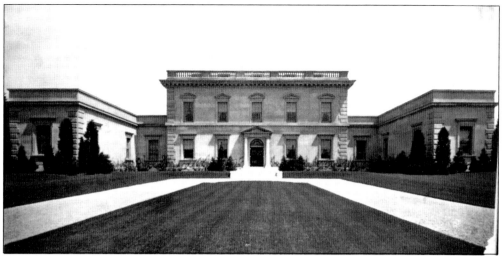

Claradon was built between 1903 and 1904 for Edward C. Knight Jr. in Newport, Rhode Island. Trumbauer also designed Knight's town house in Philadelphia. The Palladian house was named for Knight's wife, Clara. A later owner renamed the house Claradon Court. The exterior was inspired by English architect Colin Campbell's design for a house that, while never realized, was published in 1715. Claradon still stands, facing Bellevue Avenue. In 1956, the house was used as a set for the movie *High Society*, the musical version of *The Philadelphia Story*, the tale of Hope Montgomery Scott of Ardrossan.

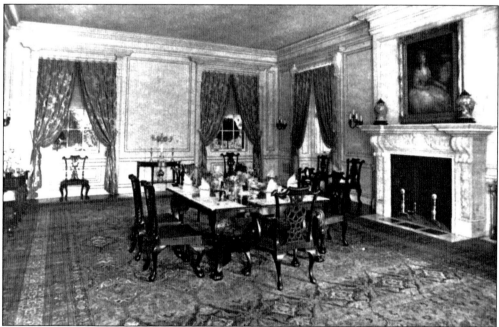

Trumbauer and Jules Allard designed and filled the rooms at Claradon. Most rooms were elegant and simple, decorated in the 18th-century English period. The dining, drawing, and breakfast rooms were located on the first floor, and the second floor contained four bedrooms, four bathrooms, and a sitting room. Claradon Court gained notoriety in December 1980 when Martha "Sunny" Crawford von Bulow was found in her bathroom by her husband, Claus, in an irreversible coma. Claus von Bulow was tried for attempted murder and ultimately acquitted.

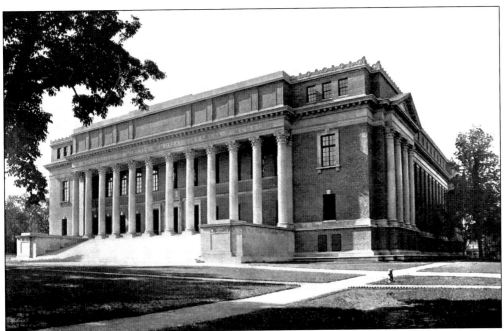

When Harry Elkins Widener went down on the *Titanic*, his will stipulated that his rare book collection be given to his alma mater, Harvard University, provided the university build a suitable home to house the collection. To ensure a fitting memorial to her son, Eleanore Widener asked Trumbauer to design a library for Harvard. The Harry Elkins Widener Memorial Library opened on June 24, 1915.

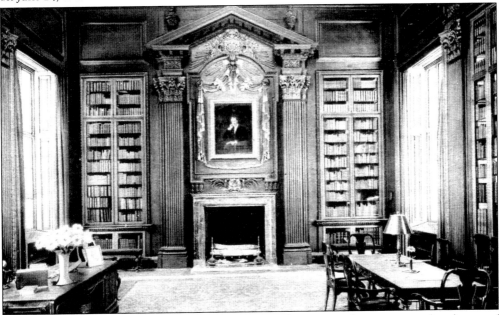

A central staircase in the Widener library leads up to the main reading rooms, and at the top of the steps, a memorial room was built specifically to house the library of Harry Elkins Widener. His book collection includes many fine and rare volumes with outstanding collections of Charles Dickens, Robert Browning, Robert Stevenson, and George Cruikshank among the treasures.

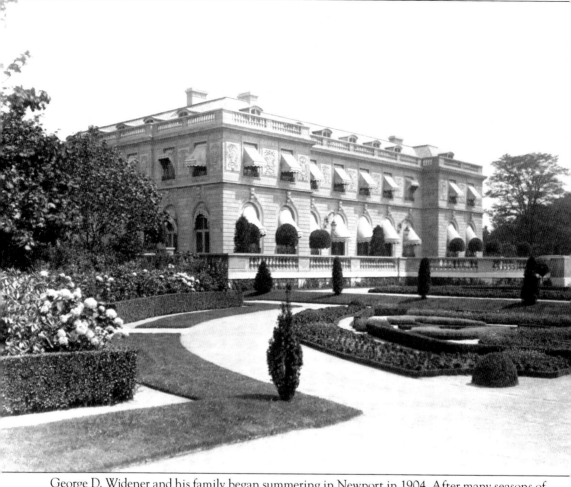

George D. Widener and his family began summering in Newport in 1904. After many seasons of renting, Widener purchased the Christopher Bell estate bordered by Yznaga Avenue, the Atlantic Ocean, the Ogden Mills estate, and Bellevue Avenue. He demolished the existing house and had Trumbauer prepare plans for a new mansion. When Widener perished on the *Titanic*, the plans for the Newport mansion went down with him. Eleanore Widener cancelled work on the house, which had already begun, but later reconsidered. Similar plans were finished in March 1913 and construction was completed in 1914. Jacques Gréber designed the formal French gardens on the Bellevue Avenue side of the mansion. At the opening of the Harry Elkins Widener Memorial Library in 1915, Eleanore met Dr. Alexander Hamilton Rice, an internationally renowned geographer and world explorer. They were married later that year. The Rices lived and entertained at Miramar until Eleanore's death in Paris in 1937. Rice was given a lifetime interest in the property. He died at Miramar in 1956. Afterwards, Eleanore's surviving children sold the home. The mansion passed from owner to owner until the early 1970s, when it became the headquarters of Andrew Panteleakis's American Capital Corporation. The mansion, which remains in mint condition, was sold as a private residence in December 2006 for over $17 million, one of the highest-priced residential real estate transactions in Rhode Island history.

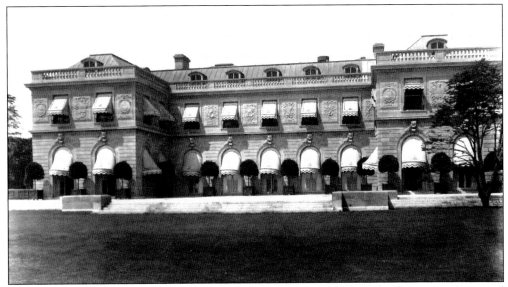

Trumbauer took his inspiration for Miramar from the design of a French Chateau in the period of Louis XVI. The H-shaped house contains 30 bedrooms and sits on a balustraded terrace. The ocean facade features two loggias and a great marble terrace overlooking a wide stretch of lawn down to the sea. The understated elegance of the details makes Miramar a fine example of French neoclassical architecture.

The service court, which is hidden by the trellis-lined marquee, is located on the north side of the house. Deliveries arrived here. Because Newport mansions are nestled on small plots of ground, the outbuildings tend to be visible from the street. Trumbauer's solution was to make Miramar's garage look like an orangerie.

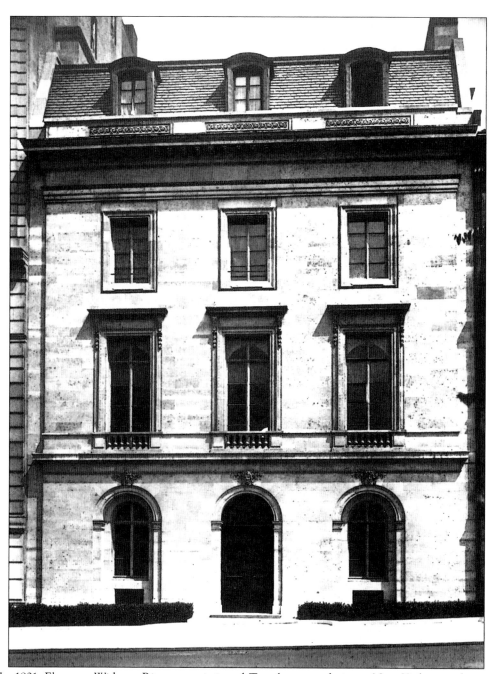

In 1921, Eleanore Widener Rice commissioned Trumbauer to design a New York town house. The French-style town house was completed in 1923. Located at 901 Fifth Avenue, the residence was the perfect place for entertaining when the Rices were not traveling in Europe, India, or South America. Upon her death, Eleanore's will stipulated that the Louis XVI drawing room and its contents were to be given to the Philadelphia Museum of Art. This was the only individual bequest she made. Rice continued to use the town house until his death in 1956, when it was sold. The Rice town house and its neighbor, the Florence Vanderbilt Twombly residence, were demolished shortly thereafter to make way for an apartment building.

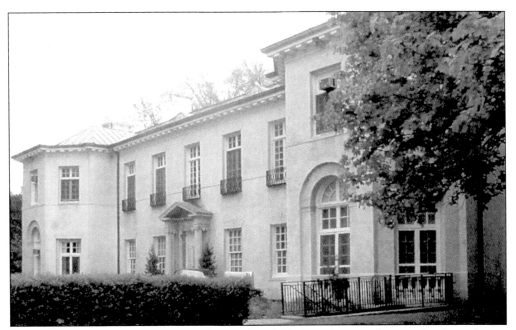

Brooklands was a wedding present from Edward T. Stotesbury to his stepdaughter, Louise Cromwell Brooks. The mansion, completed in 1917, was one of the most extravagant residences in Green Spring Valley, a suburb of Baltimore, Maryland. The mansion is Georgian in style, H shaped, and stuccoed. The estate included two guesthouses, a caretaker's house, and a garage. Louise divorced her husband in 1919 and later married Gen. Douglas MacArthur in 1922. The estate was renamed Rainbow Hill after the National Guard division so named by MacArthur. The estate's grounds have been recently developed, while the mansion stands unoccupied.

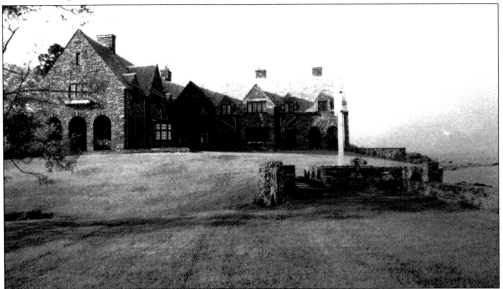

Following the death of his wife, Edward C. Knight Jr. decided to leave Claradon in Newport and build a Tudor-style cottage on the coast in nearby Middletown, Rhode Island. Named Stonybrook, the house was one of the last residential designs of note by Trumbauer for a Philadelphian. The house still stands.

DISCOVER THOUSANDS OF LOCAL HISTORY BOOKS FEATURING MILLIONS OF VINTAGE IMAGES

Arcadia Publishing, the leading local history publisher in the United States, is committed to making history accessible and meaningful through publishing books that celebrate and preserve the heritage of America's people and places.

Find more books like this at
www.arcadiapublishing.com

Search for your hometown history, your old stomping grounds, and even your favorite sports team.

Consistent with our mission to preserve history on a local level, this book was printed in South Carolina on American-made paper and manufactured entirely in the United States. Products carrying the accredited Forest Stewardship Council (FSC) label are printed on 100 percent FSC-certified paper.